IMAGES
*of America*

THE POLISH CO
OF GARY

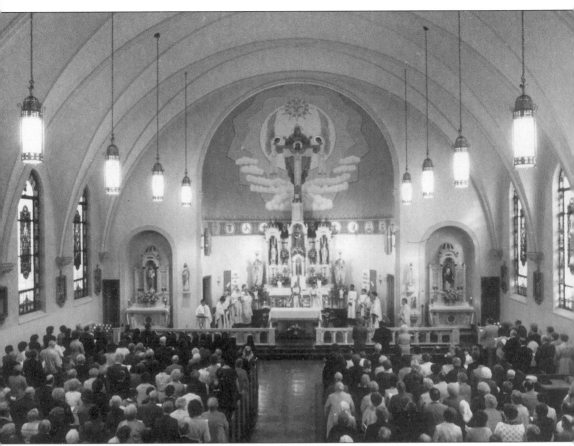

On October 16, 1983, St. Hedwig Parish observed its Diamond Jubilee. A special Mass of Thanksgiving was celebrated before a standing-room-only crowd at the church. Later that day a banquet was held at the Salvatorian Hall in Merrillville where over four-hundred parishioners and guests took part in the festivities. (Courtesy of St. Hedwig.)

IMAGES
*of America*

# THE POLISH COMMUNITY
# OF GARY

John C. Trafny

ARCADIA

Published by Arcadia Publishing,
an imprint of Tempus Publishing, Inc.
3047 N. Lincoln Ave., Suite 410
Chicago, IL 60657

Printed in Great Britain.

Library of Congress Catalog Card Number: 00-110233

For all general information contact Arcadia Publishing at:
Telephone 843-853-2070
Fax 843-853-0044
E-Mail sales@arcadiapublishing.com

For customer service and orders:
Toll-Free 1-888-313-2665

Visit us on the internet at http://www.arcadiapublishing.com

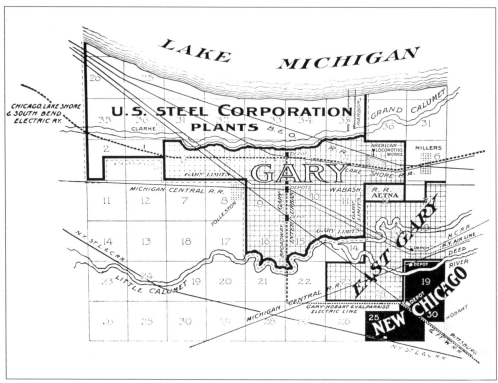

St. Hedwig Parish—an area of Gary bordered by Broadway on the west, 21st Avenue on the south, Georgia Street on the east, and the Wabash tracks to the north—was the heartland of the Steel City's rising Polish-American community. It was never homogeneous as other ethnic groups, and a few African Americans resided there before 1920. (Courtesy of Calumet Regional Archives.)

# CONTENTS

Acknowledgments                                    6

Introduction by Dr. Lance Trusty                   7

1.    1908–1918                                     9

2.    1919–1925                                    19

3.    1926–1930                                    27

4.    1931–1941                                    35

5.    1941–1945                                    49

6.    1946–1957                                    63

7.    1958–1970                                    83

8.    1970–Present                                103

Afterwards                                        126

Bibliography                                      128

# ACKNOWLEDGMENTS

The Heart of Polonia is more than the history of St. Hedwig Parish church. It is also the story of Gary's Polish immigrants and their many American descendants' journey of assimilation into American society. It presents the histories of working people who toiled in the mills, raised families, built a church, and established a community. Their stories emerged from lengthy detective work in local libraries, the Calumet Regional Archives of Indiana University Northwest, and the record of the Diocese of Gary. Bits and pieces of information were drawn from documents preserved at St. Hedwig Parish and from personal interviews. As I learned much about my own family and heritage, the process was also a personal journey.

The late Dr. Edward Zivich of Calumet College of St. Joseph first sparked my interest in local history through his course *The Immigrant Experience*. Dr. Lance Trusty of Purdue University Calumet provided encouragement and editorial assistance. Steve McShane, director of the Calumet Regional Archives, recommended many valuable sources. The professional staffs of the Gary and Hammond Public Libraries and the Diocese of Gary were of great assistance. I would also like to thank Debbie Ackerman for her assistance with the computer, and Arcadia Publishing for taking on this project. Thanks go to Mike Sharp for restoring old pictures of the parish. My sister, Diane Trafny Greenwood, typed the manuscript, and Wanda, my mother, helped with the Polish-English translations. My father, the late Steve Trafny, and aunt, Helen Lis, provided a great deal of family history for a research paper that I did on the subject in 1975.

Helen Zielinski, Henry and Evelyn Lisek, and Dennis Noskoskie provided valuable information about the parish. Other helpful parishioners include John Peck, Alice Gurniewicz, John Murajda, Bogdan Pankiw, Charlotte Angela Aldrich, Anna Kalicki, Edward Kaminski, Stanley Dabrowski, Helen Dzienslaw, Maria Mastalski, and Margaret Oleska. Several members of the Franciscan Order kindly offered their assistance and their prayers, especially Sisters Elaine Bartkowski, Virginette Rokicki, Lillian Szura, Clarent Marie Urbannowicz, and Emilie Marie Lesniak.

Of course no historical research can be perfect, and the author assumes full responsibility for any and all errors or omissions herein.

# INTRODUCTION

It is a pleasure indeed to introduce John Trafny's excellent history of St. Hedwig Parish of Gary, Indiana. John is well-qualified for this task: native and lifelong resident of Gary, and member of St. Hedwig. Since 1984 he has taught history at Bishop Noll Institute in Hammond, Indiana. Much of the work on this project was done as he earned a Master of Arts degree in history at Purdue University Calumet, which was awarded in 1999. Currently a guest lecturer at Purdue, he teaches an introductory course in American history.

*The Polish Community of Gary* provides illuminating insights into the history of the European immigrant in an industrial community, and the powerful forces of Americanization. It reveals how thousands of hopeful and hard-working Polish immigrants arrived in the earliest years of the 20th century, established an ethnic community, and adapted to the American environment. It also embraces a rather different stream of people, the "Displaced Persons" who, in the late 1940s, crossed the Atlantic Ocean to escape the wreckage of World War II and the Soviet occupation of Poland.

John traces the story of their trials, tribulations, and triumphs with skill and compassion, using their "Polish" Roman Catholic parish, rather than the lenses of industry or urbanism to define their experiences. Who cannot look at his photographs of those earnest young boys and girls posing at Confirmation or graduation ceremonies, at the priests, sisters, and church-builders, and at the serious-faced brides and grooms without marveling at the resilience of mankind?

St. Hedwig's story is also the story of Gary, Indiana, the "City of the Century," the "Steel City," the "Magic City." The parish was founded at the same instant that the giant U.S. Steel Corporation launched its brilliantly successful Gary Works. Fifteen years later St. Hedwig's was a thriving parish, and the Gary Works—now the largest integrated steel mill in the world—was the primary employer of the hundred peoples living in America's largest "company town." Gary's Polish-American "greenhorns" began at the bottom of the job and skill ladder, and worked their way into foremanships, then managerial posts, and, with the G.I. Bill and postwar prosperity, into the mainstream of American society.

Anyone with an interest in ethnic, industrial, urban, and church history, and, indeed, in people, will find John Trafny's splendidly illustrated memoir of St. Hedwig Parish of Gary, Indiana, a fine read.

Lance Trusty
Professor of History
Purdue University Calumet

# One
# 1908–1918

## Co Kraj to obyczaj
### (Every land has its customs)

Gary was divided by the Wabash Railroad Tracks. On the north side, next to the mill, was a land of neat, carefully planned neighborhoods, skilled workers, managers, and professionals. The Gary Land Company carefully screened potential homebuyers, and favored "Old Stock Americans"—the Irish, Scots, Germans, and Jews. The south side was the future home of Gary's Polish-Americans. An unplanned land of cheap boarding houses and tarpaper shacks, the south side housed the city's constant inflow of immigrants and unskilled laborers. Until the mid-1920s, U.S.S production line employees worked 7 days a week in 12-hour "turns." They also endured a "double-turn" every two weeks—a 24-hour stint that arrived automatically with shift changes. In 1910, the company paid its unskilled laborers 17¢ an hour.

The "Patch," later known as the Central District, was the most notorious section of the city. In 1909, about half of the city's saloons were located there in what seemed a slice of the old Wild West. Immigrant bachelors and families lived in its primitive dwellings. Everyone worked. Some drank, fought, died, gambled, or spent money on prostitutes. Most saved their money for a better life, to return to their homeland, or to live in some comfort. For several years after their arrival in the United States, most of the men lived in all-male boardinghouses. By the 9th year, however, frugality and steady work allowed immigrants to bring brides or their families form the old country.

The south side was much more than a slum. It was, like nearby Indiana harbor, a port of entry. With the passage of time, Polish immigrants, like others, acquired skills and moved up the job ladder. They built homes on lots purchased from the Gary Land Company or local realtors. As time passed, more and more Polish-American families found places in a community of tree-lined streets and nice lawns. For even the less-skilled immigrants the American dream worked: eventually most could manage a cottage, perhaps better food and clothing, and even a few personal luxuries

In traditional Polish families, the father was presumed to be dominant. The mother was expected to remain quiet and subservient. Yet family life was exceptionally stable. Single or divorced women had few options. Polish women had limited knowledge of the English language, few job skills, and a social and religious heritage that determined their daily lives far more than wayward husbands.

Polish-American homes in Gary were usually much larger than the tenements of the Patch or Hunkeyvilles elsewhere. They had to be: immigrant families often large, despite the high rate of infant mortality. Boarders helped make ends meet, but the birth of another child often meant the boarder had to move on. Many lived in extended families. Sometimes the parents of one spouse, sometimes a brother, a recent immigrant friend, were part of the household. The income was essential for many, but the demands of a growing family, a variety of relatives, and a collection of boarders drained immigrant women.

In the earliest days, Gary Polish families worshiped in either East Chicago, Hammond, or Whiting. Traveling between Gary and those nearby cities was not easy. The availability of lots for churches through the Gary Land Company sparked the drive by Polish immigrants to build their own church in a "nationality" parish with a Polish-speaking priest.

The language barrier in non-Polish churches was a crucial factor. Receiving the sacraments was difficult

for non-English speaking Poles. Poles could attend mass in other cities on Sunday, but felt like visitors in a foreign church. What good was confession to a priest who did not understand a word of what was being said?

At the 1907 meeting, Gary Poles formed the St. Hedwig Administrative Committee to raise funds and plan for a church and a school. Its members were Peter Pisarski, Valentine Fabjanski, Valentine Nowak, John Wasilewski, and Frank Zawadski. On the day after the meeting, Gary Polish families and nearby small businesses donated $150 to the project. Every family in the general area contributed what it could.

The entire Polish-American community helped raise funds with picnics and social events, and soon collected $900. But the required sum, $15,000, seemed unattainable, so the committee wisely modified its original plan in favor of a more modest frame church, to be constructed on seven lots donated by the Gary Land Company.

With construction completed, on July 4, 1908, the Most Reverend Bishop Herman J. Alerding arrived to bless the building and dedicate the new parish to St. Casimir, a name soon changed to avoid confusion with St. Casimir Parish on the North Side of Hammond. The new parish was named St. Hedwig, for *St. Jadwiga*, Poland's patron saint.

The Rev. Anthony Stachowiak, who tended to a parish in Indian Harbor, became St. Hedwig's first pastor. On July 6, 1908, he presided over the first marriage in St. Hedwig, uniting Victor Majewski and Veronica Naruszewicz. St. Hedwig's first resident pastor was the Rev. Peter Kahellek, who arrived in 1909.

Calumet Region Poles believed that parochial schools were the key to maintaining a strong Catholic faith and awareness of old country language and culture. They preferred bilingual teachers, but as enrollments increased, nuns—who worked for even lower wages—appeared in the parish schools.

Their mission was to teach the children of immigrant Polish families, but most had little more than a basic education, and only a few had been fortunate enough to gain a formal college education. They remained committed to poverty, chastity, and obedience, and worked long hours, seven days a week. They taught the children of the parish school and worked at the convent and church each day.

Many parents who enrolled their children at St. Hedwig had never attended school, so the parish sisters tried to give their students the education the adults never had. Classes of 30 to 50 students were common.

On July 13, 1917, the parish decided to build a much larger combined church and school building. The top floor would become the church and the lower floors would house the school. Each parishioner was asked to donate an additional $25, no small sum in an era of nickel and dime Sunday offerings.

On June 30, 1917, bids for the construction of the building at the corner of 17th Avenue and Connecticut Street were opened in the office of the architect, Herbert Erickson. Several local contractors had submitted bids; the winner was John Wasilewski, a founding member of the parish and the first Polish contractor in Gary. Construction of the $45,000 structure was completed the following year. The new building served the upper five grades, and the old building was assigned to the kindergarten and the first three grades.

On April 13, 1918, as many young Polish Americans were far away serving in the war, Bishop Alerding of Fort Wayne dedicated the new St. Hedwig church-school complex on 17th Avenue. Three thousand parish members and guests paraded through the neighborhood as part of the ceremony of dedication.

The city of Gary was about 30 percent Roman Catholic, but nearly half of those children did not attend parochial schools. Only one in a hundred attended the region's only local Catholic high school, Hammond's Catholic Central (later renamed in honor of Bishop Noll) after it opened in 1921. Many Gary immigrant children avoided the parochial schools because of cost, and because of Gary's remarkable public schools. Yet many Roman Catholic immigrants regarded secular public education as a threat to their culture and religious heritage. To them, the forceful "Americanization" of the day was a threat that the parochial schools could ward off.

During the 1920s, St. Hedwig—the largest Polish parish in Gary—was bursting at the seams with new parishioners. In the eight years after its founding in 1908, 1,389 children were baptized within its walls. In 1916 alone, there were 442. On some days the pastor conducted two dozen or more baptismals. In the six years before 1923, 1,404 parishioners received the sacrament, and by the end of 1930, a total of 3,411 had been baptized in St. Hedwig. Between 1908 and 1930 over 600 weddings were performed in the parish church. No exact figures are available regarding the exact numbers of students attending St. Hedwig School, but during the busy 1920s, over 900 children were enrolled annually.

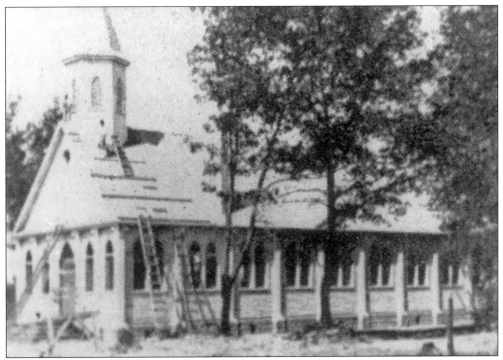

In the spring of 1908, contractor Anthony Bankus, assisted by John Wasilewski and John Jendrzejewski, began construction of St. Hedwig Church. The site was amid forest and sand dunes with neither streets nor streetcars. Volunteers pitched in and soon the construction site was a busy place. (Courtesy of St. Hedwig.)

Father Kahellek was born in Swieta, County of Zlotowo, Pomorze (Pomerania) in 1865. He was educated there, and served in the army with a lancers regiment in Toron. Ordained in Cincinnati, Ohio, Father Kahellek then served several parishes in Northern Indiana. He supervised the organization of St. Adalbert Parish in Whiting in 1901, and then moved to St. Hedwig. (Courtesy of St. Hedwig.)

11

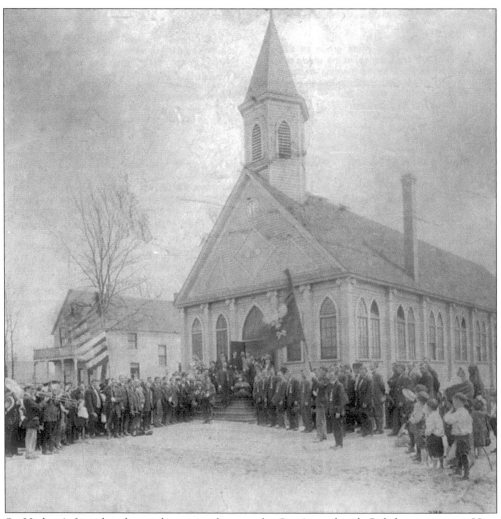

St. Hedwig's first church was the spiritual center for Gary's south-side Polish community. Here parishioners gather for the funeral of a former parishioner. At left a band plays somber music for the occasion. (Courtesy St. Hedwig.)

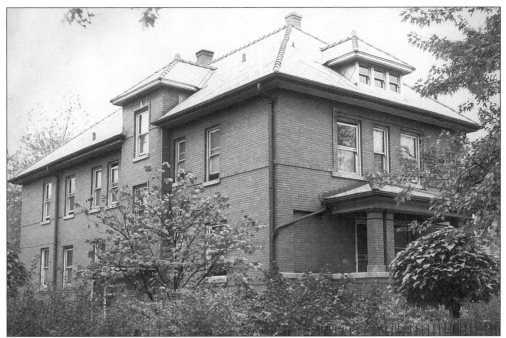

At first the sisters lived in the original school building, but the sudden and large growth in school enrollment forced them to seek new quarters. A convent was constructed in 1913 in the 1700 block of Pennsylvania Street. It served as the Franciscan Sisters' residence for over 60 years. (Courtesy of St. Hedwig.)

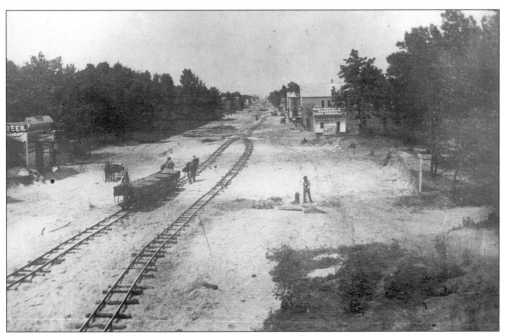

Above is an early view of 19th and Broadway looking north in 1907. As time passed the trees were cleared to make room for business and residential lots. The watering hole at the left probably catered to many of the workers, as well as the locals. (Courtesy of Calumet Regional Archives.)

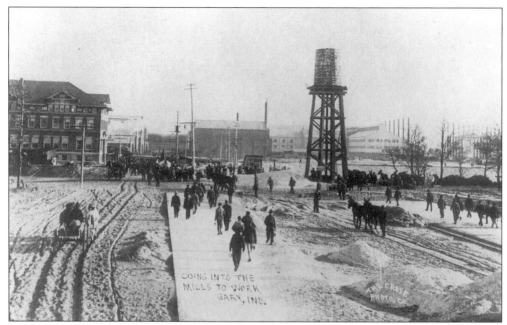

Steelworkers head for the Gary plants' Broadway gate for another grueling day in 1910. Until the mid-1920s, Poles and other immigrants on the production line worked 6 to 7 days a week in 12-hour "turns." They also endured a "double turn" every two weeks—a 24-hour stint that arrived automatically with shift changes. (Courtesy of Calumet Regional Archives.)

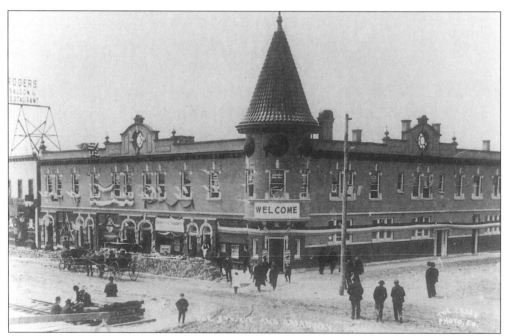

Gary's transportation system was being developed on both sides of the Wabash tracks along Broadway prior to World War I. Though traffic lights were not in use, rails for streetcars were installed to link all sections of the city. At the time, the hotel at 9th Avenue was being used as the Democratic Party headquarters. (Courtesy of Calumet Regional Archives.)

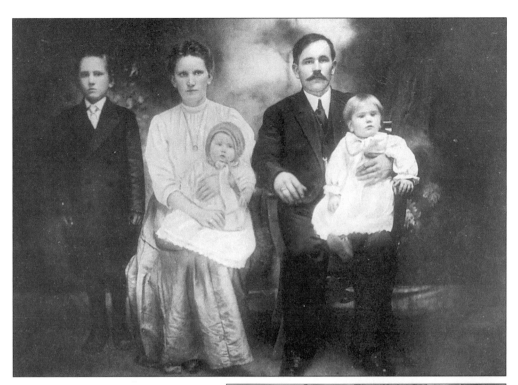

Michael Trafny epitomized an oft-told tale in Gary's Polonia. He came to America to work, build a savings, and return home. But wealth was not in the cards. Trafny first worked in a Minnesota lumber camp, then moved into the South Chicago home of his brother-in-law Walter Malec. Both found jobs in the new Gary Works and homes near St. Hedwig Parish. Pictured left to right: son Peter, with Marianna holding daughter Helen, and Mike holding son Stephen. (Courtesy of Dolly Trafny.)

While many Poles returned to Eastern Europe after a few years, the majority planted permanent roots in the Steel City. Workers purchased lots and homes in the Central District from the Gary Land Company. Though the dwellings were modest, they made the Poles property owners and set them on the road towards assimilation into American society. (Courtesy of Calumet Regional Archives.)

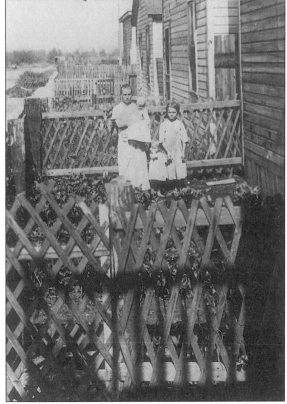

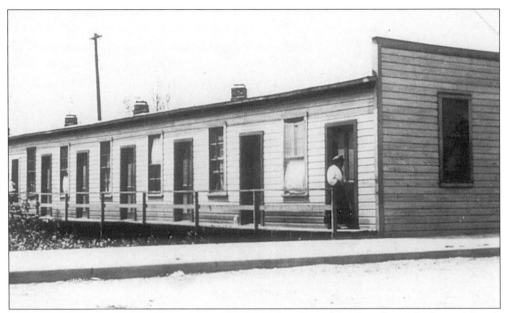

Immigrant housing was not always a nice house with a fenced yard in the early days of Gary's Polonia. In 1918, an area at 19th Avenue and Massachusetts Street, known as Shacktown, provided basic shelter for the new-coming immigrant families. The structures were cramped, one-story, wooden row houses. (Courtesy of Calumet Regional Archives.)

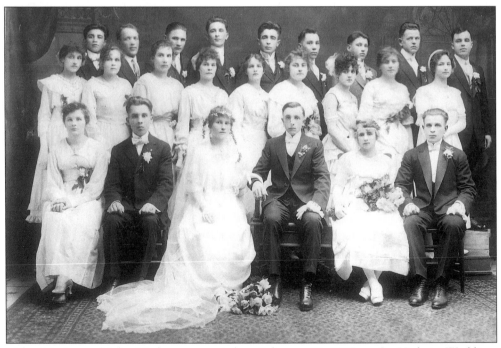

Helen Maciag and John Lisek were married on February 18, 1917, at St. Hedwig. Weddings were lavish celebrations that often preserved or adapted old Polish customs. Most took place in the fall before Advent, between the New Year and Lent, or in the spring or summer. (Courtesy of Henry Lisek.)

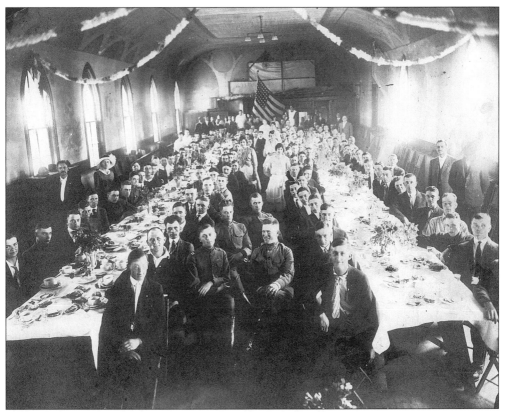

Patriotic events were held throughout the Steel City during the Great War of 1917–1918. This dinner was held in the old St. Hedwig Church. Notice the "Doughboy" captain and his fellow troopers in the lower middle of the picture. (Courtesy of St. Hedwig.)

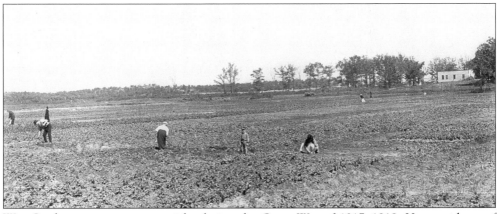

War Gardens were a common sight during the Great War of 1917–1918. Here residents of Gary's Central District tend to their crops. The photographer was looking east near 25th Avenue. (Courtesy of Calumet Regional Archives.)

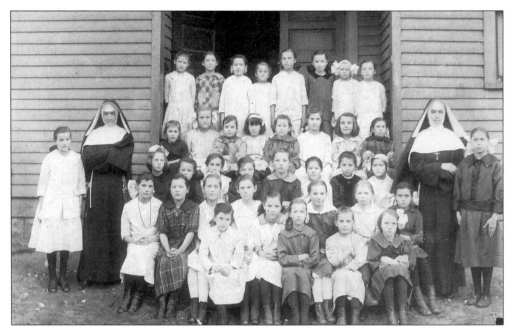

St. Hedwig girls and sisters are photographed in front of the old school before World War I. The nuns did their best to help the students succeed. Rarely the tyrants of popular legend, most were dedicated women who sympathized with the hardships of the immigrants. Their own families had met the same challenges. (Courtesy of St. Hedwig.)

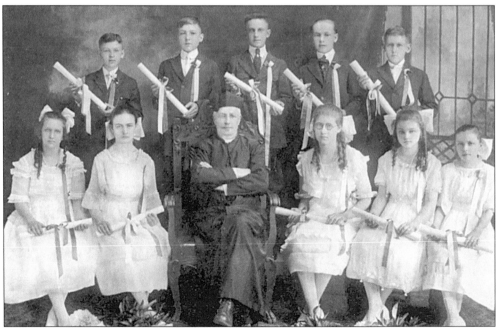

Members of the St. Hedwig's first graduating class were awarded diplomas in 1915. There were ten students in the group. Standing, from left to right, are J. Malak, J. Siemion, J. Bartkowski, C. Goszczynski, and J. Marzalek. Sitting, from left to right, are E. Jabczynska, M. Lello, Fr. Kahellek, A. Golkowski, H. Sazastakowski, and C. Rzeplinska. (Courtesy of St. Hedwig.)

# *Two*

# 1919–1925

## CZLOWIEK JEST KOWALEM SWEGO ZYCIA
### (MAN IS THE MAKER OF HIS DESTINY)

The Great War of 1914–1918 and the Great Strike of 1919 shattered Polish-American hopes for a return to the homeland. These closely-related events also forged a permanent bond between Polish Americans and the United States. When the Great War began, 40,000 Polish Americans and immigrant Poles enlisted to fight for Poland and the Allied cause in the hope that victory might free their homeland. Many Polish Americans were seasoned combat veterans long before America entered the conflict in the spring of 1917.

Suddenly Polish immigrants, if not their American-born children, had to decide whether they were Poles or Americans. Forty-thousand returned to Poland immediately after the war and confirmed their Polish heritage. The "hyphenated" majority that remained in the United States would become Americans. Local Polish newspapers, such as *Chicagoski*, argued that older Poles and those born in Poland naturally preferred their native land. Younger Poles remained, the editor wrote, because they were Americans.

The Great Strike of 1919 involved thousands of local Polish-American steelworkers. Their demands dealt with "bread and butter" issues, though Big Steel successfully tarred their "Hunkey union" with charges of radicalism. The AFL-endorsed steelworkers union called for abolition of the 12-hour shift, better wages, retention of collective bargaining, and the reinstatement of workers fired for union activity. Widespread employment of strikebreakers provoked violence in October 1919. In Gary, as a paralyzed state militia watched, 2,000 strikers ignored an anti-parade ordinance and marched through the streets.

That was enough for public opinion and the mill masters, and the federal troops were dispatched from Fort Sheridan, Illinois. The politically ambitious General Leonard Wood described Gary as a hotbed of anarchy, and used his forces to break the strike and destroy the union.

After the war and the long, disastrous strike, Gary's Polish Americans settled down to join the American mainstream. The United States was now their country and American business was now their own. The strike had failed, but Poles and their fellow immigrants had learned enough about workers' rights to help lay the groundwork for a reborn labor movement in 1930s.

Their Americanization was still in process. Social, political, and economic involvement in their community and the larger society grew steadily. One helping hand was extended in 1919 by a new branch of the International Institute. Organized in Gary by a trained social worker, Agnes B. Ewart, and four nationality workers, the agency first met in a south side branch of the Gary Public Library. Unlike many local social service agencies, the Institute hoped to serve the immigrant community's needs while preserving ethnic identities.

U.S. Steel also accelerated the Americanization process. Wartime in-plant mass rallies were arranged for both patriotic and propaganda purposes. Production quotas were announced, and records were often broken. Poles and other immigrants contributed both to the war effort and corporate profits. After the war, the keys to plant survival and to rising were English, training, and education. In the always-dangerous steel mills, the illiterate greenhorn who could neither speak English nor read Polish was considered a threat to his co-workers.

Language identified origin, and without English, survival in America was difficult, success impossible. Without English, one remained a permanent greenhorn, and so, predictably, the second generation focused on English in the schools and ignored their family tongue. Parents willing to learn the language asked their children to speak English at home. Education helped most, but not all Polish immigrants. First generation settlers often remained tied to their peasant roots, and never mastered the skills that would have allowed them to get a more technical or skilled job. Few aspired to the professions, though some practiced law and medicine in the Central District. Most Poles, like other Eastern European immigrants, lacked the money and time to invest in such ambitions.

In 1923 Dom Polski, the Polish Home Society, was organized and built a hall that provided Gary's Poles with a community center for social gatherings, weddings, and lodge meetings. Space was scarce, as groups and families could not always rent a parish hall. Lodges and hall owners profited from rentals, catering, and of course, the mandatory, well-stocked bar.

In 1925, two dozen sports-minded men of Polish and other Slavic backgrounds organized the Silver Bell Club of Gary under the Polish National Alliance. Members lived in the St. Hedwig neighborhood, and the parish church served as the organization's center. In the 1920s the group participated in boxing, baseball, and basketball. On April 11, 1926, fifteen St. Hedwig Parish veterans of the Great War organized American Legion Post 207, naming it in honor of Revolutionary War hero Tadeusz Kosciuszko. In the 1920s perhaps one in five Polish Americans in Gary were professionals and storekeepers. Several immigrant or second generation Polish-American doctors and lawyers practiced in the area, and enriched community life. Every block and sometimes all four corners at intersections featured Polish-owned mom-and-pop grocery stores, bakeries, butcher shops, clothing stores, funeral parlors, drug stores, and taverns. Furniture stores and banks of greater size also operated within the parish.

Among these stores were the Federal System of Bakeries at 1500 Broadway, and, some blocks to the east, the Jatczak brothers' Virginia Street Bakery. A visit to the Boleski family bakery across the street from the convent at 1701 Pennsylvania Street was mandatory for Sunday parishioners and St. Hedwig school children.

Ladies loved the fancy hats at Felycia Ignac's millinery at 1623 Broadway, or at the H. Spychalski shop two blocks south. In trouble with your sweetheart? Buy flowers at Elliot Kwiaciarz's flower shop on Broadway. Mr. Kwiaciarz's motto was *Muwcie z kwiatami* (Say it with flowers.) W. Chmielarski ran the Polish National Real Estate Bureau at 17th and Pennsylvania Street. From offices on East 16th Avenue, the C.M. Nowak company bought and sold homes and farms and relayed money to Poland. Two major furniture stores were located in the Central District along Broadway.

Polish-owned drug stores were plentiful. The South Side drug Co. did business at 101 Broadway, and J.F Kobylanski operated a pharmacy two blocks north. At 17th and Broadway, the Economical Drug Store catered to Polish and Russian clients. And L. Szostakowski awaited those beyond medical assistance at his funeral home on Connecticut Street.

V. Tomaszewski operated a painting firm at 1700 Connecticut Street, and W. Lewandowski owned the Gary Hardware Company at 1624 Broadway. W. Yavanowich's Virginian Dairy sold milk and cheese at 1600 Virginia Street. Two Polish-owned pool halls racked 'em up in the Central District. The White Eagle Billiard Parlor and Barber Shop was located at 1632 Broadway. A few blocks east, men assembled at the Polonia Pool Room at 30 East 16th Avenue.

Several Polish medical professionals practiced within walking distance of the neighborhood. Dr. John Stawicki, M.D., opened his office in 1913. Dr. Joseph Sponder, M.D., studied at the Jagielonski Medical School in Krakow before coming to America. Other physicians were Dr. D.L.J. Danieleski and Dr. Stanley Majsterek. Legal services were provided by several Polish-American lawyers. Three dentists, Dr. Julia Kalin, Dr. A.M. Jozefczyk, and Dr. C.L. Troop, maintained offices in the 1500 block of Broadway.

Around 1920, two weekly Polish-language newspapers were published in Gary before the Great Depression. Editor Anthony Berele managed *Glos_Lindu*, the *Voice of the People*, while John Jasenski began publishing *Glos Polonji*, the *Polish Voice* at the same time.

In the mid-1920s the St. Hedwig community closely resembled the other ethnic neighborhoods in the booming city of Gary. Residents of Gary's close-knit *Polonia* purchased their daily needs from shops within walking distance of their homes, usually from other Polish Americans. Storeowners knew most residents by their first names. Neighbors knew neighbors, and, often, too much of their personal business.

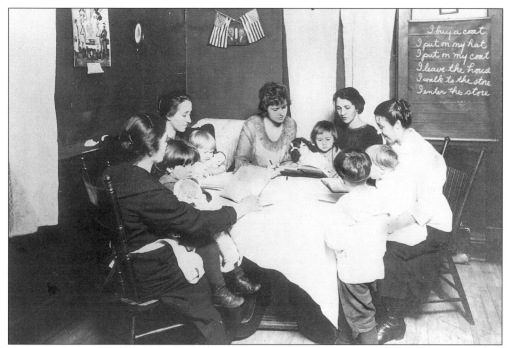

The International Institute considered preservation of ethnic heritage vital to a more democratic American society. Pride of heritage was encouraged through various social activities, English lessons, and advice on the American way of life. Dances, folk nights, and dinners allowed Poles and other ethnic groups to meet one another. (Courtesy of Calumet Regional Archives.)

In its early days, the International Institute was located near Froebel School. The agency helped Gary Poles with legal problems and citizenship, located faraway relatives, and wrote and translated letters. Unemployed immigrants were assisted in finding work. Sometimes assistance was provided in divorce cases. One angry wife accused her spouse of loving her less than the good times he carried in a bottle in his coat pocket. (Courtesy of Calumet Regional Archives.)

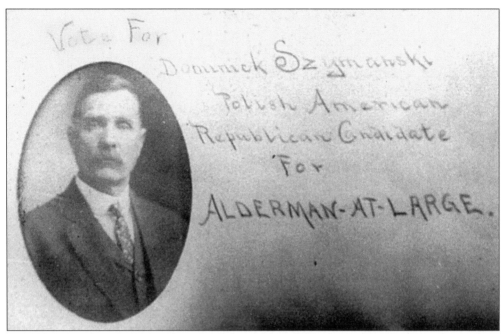

Assimilation meant voting and running for public office. As early as 1910, Poles such as Dominick Szymanski ran for the Gary City Council. The Polish-American Republican was successful in his bid, as the Steel City had a two-party system. Today, few Republicans even run in Gary. (Courtesy of Calumet Regional Archives.)

For many Polish immigrants, assimilation into the American mainstream meant a job, home ownership, and a basic education for their children. But others took it a step further and went into business for themselves. Pictured is the family of Peter Studencki around 1920. The Polish entrepreneur ran the Southside Boot Shop at 1408 Broadway. (Courtesy of Evelyn Lisek.)

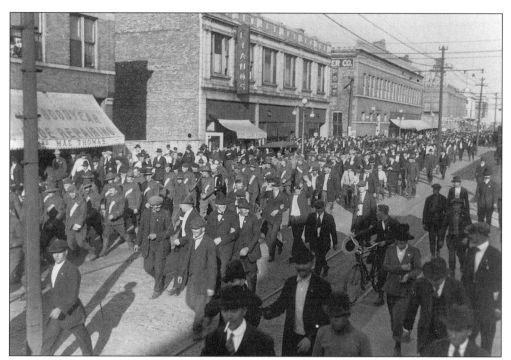

During the Great Strike of 1919, two-thousand Poles and other immigrant strikers ignored an anti-parade ban and marched along West 5th Avenue. Some even wore their old World War I uniforms to the gathering. The event displayed a spirit of solidarity between the men of steel. Sadly, it was not to last. (Courtesy of Calumet Regional Archives.)

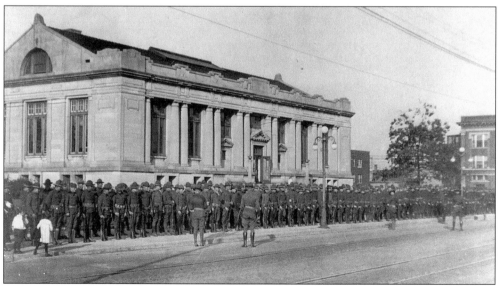

Federal troops, under the command of General Leonard Wood, assembled before the library on West 5th Avenue in 1919. The city was placed under martial law, and private homes were sometimes raided. Local newspapers claimed that the immigrants, strikers, the union, and the Reds were cut from the same cloth. In time, the union was broken, and the bitter strike came to an end. (Courtesy of Calumet Regional Archives.)

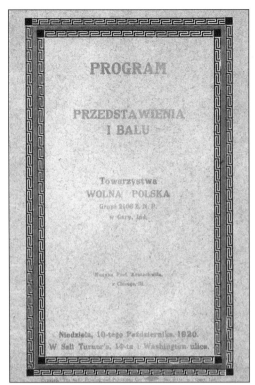

PROGRAM

PRZEDSTAWIENIA
I BALU

Towarzystwa
WOLNA POLSKA
Grupa 2106 Z. N. P.
w Gary, Ind.

Muzyka Prof. Krotochwila,
z Chicago, Ill.

Niedziela, 10-tego Października, 1920.
W Sali Turner's, 14-ta i Washington ulica.

As the St. Hedwig community grew, cultural events were held on a regular basis. On October 10, 1920, the play *Blazek Opetany* and ball was held at Turner Hall at 14th Avenue and Washington Street. Wolna Polska (Free Poland Society, Group 2106) sponsored the event. (Courtesy of Evelyn Lisek.)

Pictured is a group from the Polish Women's Alliance at St. Hedwig around World War I. Ladies' societies were part of community life going back to the earliest days of the parish. Beneficial (or burial) organizations emerged with close links to the local neighborhood, and offered a helping hand during life's major crisis. (Courtesy of Evelyn Lisek.)

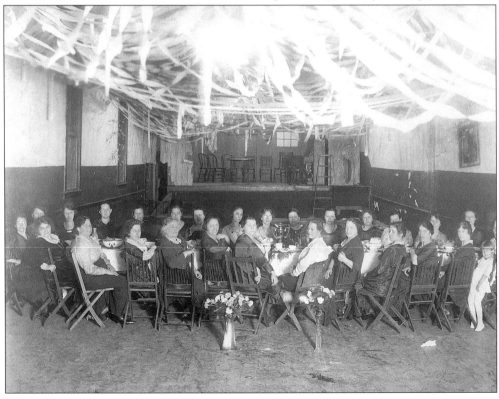

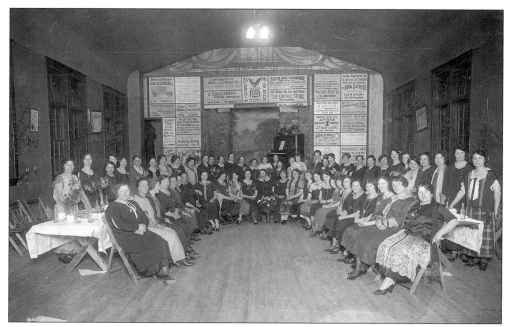

Though the event is long forgotten, the women pictured were members of the Polish Women's Alliance at the White Eagle Hall before 1920. The group provided a social outlet for women at St. Hedwig. More important, the P.W.A. helped preserve Polish customs and traditions for future generations. (Courtesy of Evelyn Lisek.)

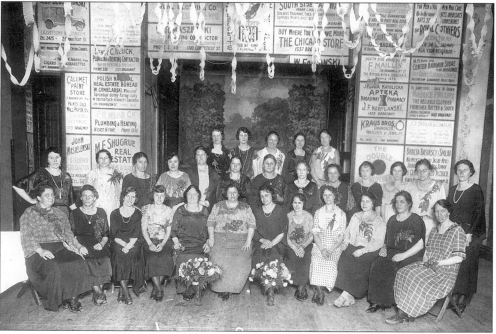

In 1923, the Ladies of the Liberty Club honored Mrs. William Marquardt with a surprise farewell party. The event took place at the White Eagle on East 17th Avenue. Notice the stage wall and curtain offered space for local businesses to advertise their goods and services. (Courtesy of Evelyn Lisek.)

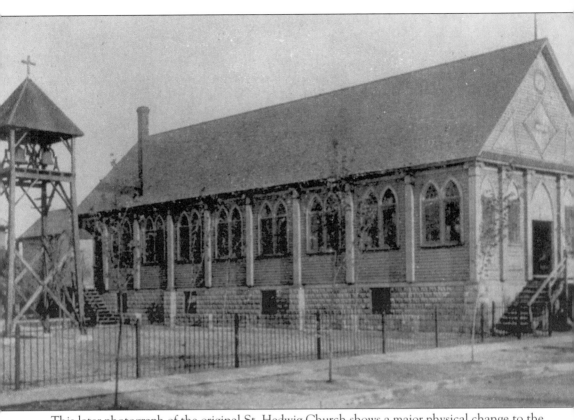

This later photograph of the original St. Hedwig Church shows a major physical change to the building. The bell tower was removed from above the main entrance. Instead, the bells sit atop a separate structure to the left. (Courtesy of St. Hedwig.)

# *Three*

# 1926–1930

## Oszczednoscia I praca, ludzic sie bogaca
### (If you work and save, you will be rich.)

During the 1920s, the city of Gary experienced rapid business and industrial expansion. As the average American city increased in population by 20 percent, Gary doubled in size. A remarkable 40 percent of the people in the booming city owned their own homes. Over 14,000 dwellings were built, of which 1,800 units were in sometimes elegant apartment houses. In the six years after 1923, the Gary Building Department issued $79 million in new construction permits. Nearly all the growth was the byproduct of a vigorous steel industry in a city with few small companies.

Gary became the commercial and cultural center of the Calumet Region in the 1920s. The completion of the impressive, 400-room Gary Hotel in 1927 increased the city's hotel space to 1,800 rooms. A dozen or more movie houses served the Steel City. Other prominent new structures included the Masonic Temple, the Knights of Columbus headquarters, and the Gary State Bank Building. The twin City Hall and County Buildings of the Gateway Center marked the arrival of Gary as a significant city. The city's mostly small retail stores provided over 4,000 jobs at 1,300 locations in 1929, supported by annual sales of almost $50 million.

The boom certainly helped St. Hedwig Parish, now with 500 member families. By 1926, over 550 children attended St. Hedwig School, where tuition was a modest 75¢ a month for the first child, 50¢ a month for the second child, and 25¢ each for additional children in the family. After Father Peter Kahellek's asked for a special donation, parishioners underwrote a new rectory at 18th Avenue and Pennsylvania Street, and even reduced the parish debt. In January of 1927, the last mortgage payment of $2,216.61 was made on the church-school, and the parish was finally debt-free, with a handsome surplus of $10.60. Two years later, when the fiscally astute Father Kahellek retired, $14,741.18 rested in the church treasury.

Marriage records, which provide the place of baptism, offer good background sources for the origins of parish membership. Roman Catholic Poles received that sacrament immediately after birth, and the place of birth and baptism were usually the same. From 1908 until 1914, less than two-dozen of the 470 people married at St. Hedwig had been baptized in the United States. Of those baptized abroad, 166 had received the sacrament in Russian Poland, 90 in Austrian Poland, of whom 20 cited Galicia as their place of baptism. After leaving Eastern Europe, many of the early members of St. Hedwig Parish had lived in Pennsylvania before moving to Gary. Frank Noskoskie came to the Steel City after a mine closed. Ferdinand and Mary Ann Dabrowski moved to the region seeking better wages. Helen Zielinski arrived in the area as a little girl with her parents Frank and Aniela Kloc, and Joseph and Anna Pechukevich (Peck) left Coalport, Pennsylvania, and settled in Gary.

The rise of a united and independent Poland in 1919 changed baptismal records. Two-thirds of those married in 1924 at St. Hedwig gave "Poland" as their place of baptism, while the rest listed cities in the United States. At mid-decade, the origins of those marrying in St. Hedwig Parish were evenly divided between Poland and America. Twelve were baptized in Chicago, five in Pennsylvania. In 1929, eight

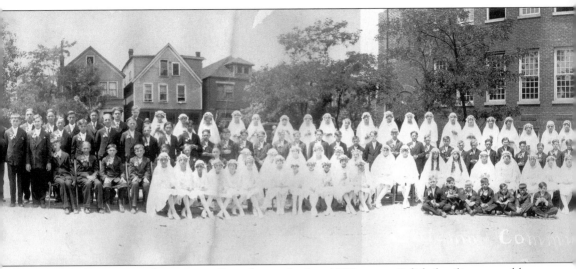

With the economy booming in Gary during the late 1920s, more Polish families were able to provide a Catholic education for their children. Nearly 600 students attended St. Hedwig School. On June 12, 1927, nearly 250 children made their First Communion. Most were from

parishioners claimed Eastern European origins, and eight provided locations in the United States. Gary and Chicago were most often listed as places of baptism. Those who listed Texas and Colorado as their baptismal homes came from families that had come to America well before 1880.

By 1930, when thirty-two marriages took place in the parish, only ten individuals gave Poland as their place of baptism. The rest had received the sacrament in America. Sixteen had been baptized in Chicago, ten in Pittsburgh, four in South Bend, and sixteen in Gary. The effect of the closing of the Golden Door by Congress in the early 1920s was plain to see.

In 1930, St. Hedwig was the largest Polish parish in Gary. Two other parishes, Sacred Heart in Tolleston and Holy Family on Ridge Road in East Glen Park, contained large Polish populations. Holy Family was established in 1926 by Poles moving to fast-growing Glen Park. Some families divided their membership between St. Hedwig and Holy Family, but in general, the first generation remained with the old church, while the younger second generation joined the Glen Park parish.

Though Poles were very much part of urban Gary, many nurtured their rural roots on hobby farms near the border of East Gary (Lake Station). Making a living was not their purpose; men and women alike enjoyed raising field and garden crops, tending a few pigs, cows, or chickens, and, perhaps, pretending for a moment they were back in their home villages.

Immigrant women rarely worked outside the home. Husbands were adamant: "as long as I put bread on the table, Mama stay home." A friend of Helen Kloc Zielinski had a small farm with some cows and hogs. When Helen screamed as he slaughtered a pig, she was told to be quiet or the pig would suffer longer. According to Polish folklore, if one felt sorry for a pig, it would put up a greater fight to live.

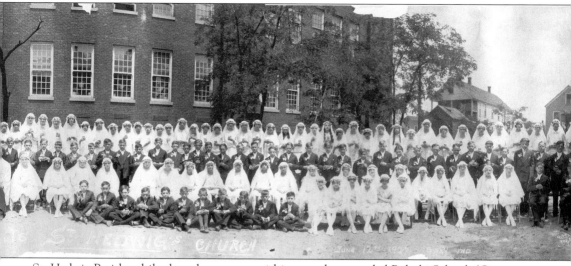

St. Hedwig Parish, while the others were parishioners who attended Pulaski School. (Courtesy of St. Hedwig.)

Prohibition, at least officially, closed the saloons from 1920 to 1933. But local citizens found abundant ways to whet their whistles. Some imported liquor from soaking wet Chicago, while others made their own. Despite the risk of arrest or explosion, stills were plentiful in Gary's immigrant community. Helen Zielinski's father Frank had two gallons of alcohol stored in his basement. One evening there was a knock on the door. When her father asked who it was, someone replied, "Police." Frank rushed to empty the bottles, then opened the door. The caller was a friend. One man's joke became another man's loss. After a still near 21st Avenue exploded and rocked the surrounding area, Monica Alabdruczynski destroyed her husband's still. But Michael Trafny and Walter Malec continued to make their own sauces, for, of course, purely medicinal purposes.

Poles were often clannish when dealing with outsiders, for good reason. Mill foremen often exploited their illiteracy and poor English, and merchants sometimes took advantage of unwary ethnic customers. Yet the immigrants continued their journey towards Americanization. New citizens joined the democratic process, and some ran for public office.

By 1930, Gary's Polish community was clearly merging with the American mainstream, while the parish church still nurtured old world customs and traditions. Parish schools educated and Americanized children and taught them their common heritage. The people of St. Hedwig Parish and the city of Gary had achieved much, but they were about to undergo the twin challenges of the Great Depression and, 10 years later, the Second World War.

The Rev. Louis J. Ratajczak served St. Hedwig from July 1924 to April of 1929. He assisted the parish pastor, the Rev. Peter Kabellek. (Courtesy of Evelyn Lisek.)

Friends and business associates gather together for a dinner hosted by Walter Tolpa during the 1920s. He founded and operated American Furniture Company in Gary's Polish business district. (Courtesy of Evelyn Lisek.)

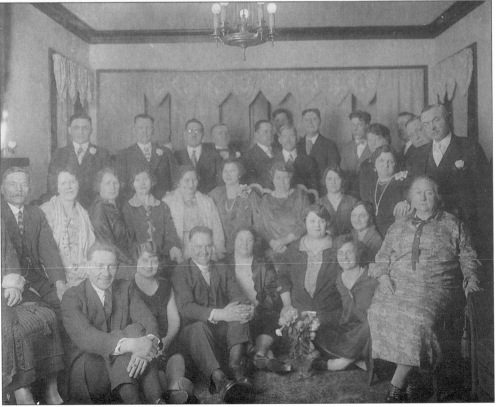

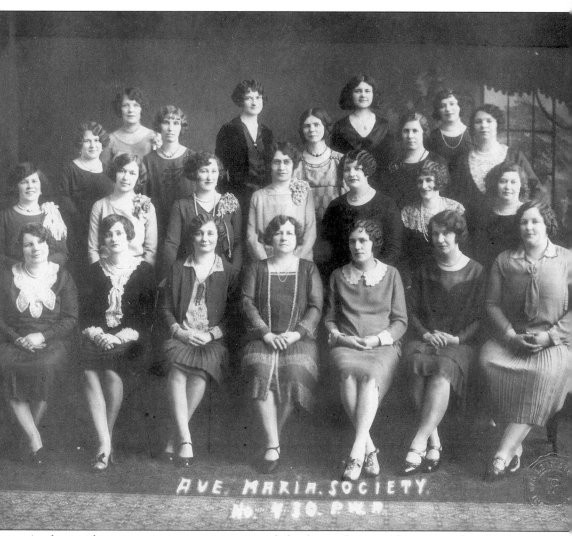

As the parish community grew, women joined the fraternal groups that operated under the banner of the Polish Women's Alliance. An early 1920s photo shows the members of St. Hedwig's Ave Maria Society, Group 430. (Courtesy of Evelyn Lisek.)

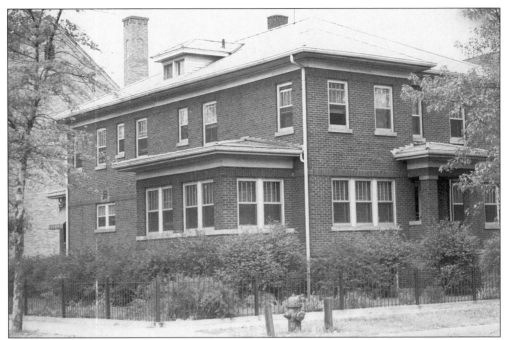

St. Hedwig's Parish Rectory is viewed from the intersection of 18th Avenue and Pennsylvania Street. Constructed in 1924, the building served as the residence of the parish pastor and assistant pastors until the mid-1980s. It still houses the parish office staff and is used for meetings. (Courtesy of St. Hedwig.)

There was some social integration during the early years of the Steel City. Students for St. Hedwig who went on to high school attended the multi-ethnic, multi-racial Froebel School at 15th and Madison Street. Sadly, in the 1920s most students went to work after completing the 8th grade. (Courtesy of Calumet Regional Archives.)

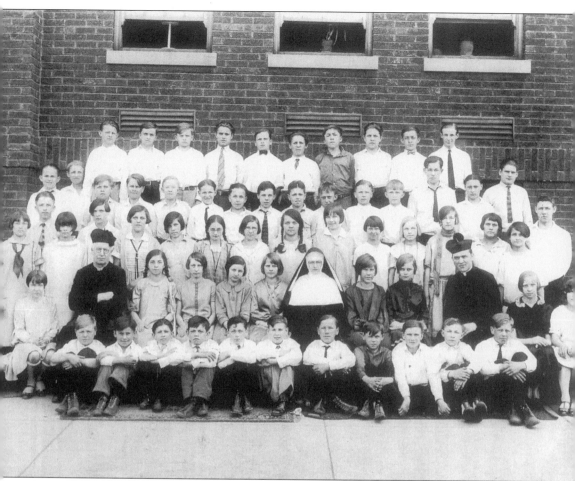

Assistant pastor, the Rev. Louis Ratajczak poses with the 6th and 7th graders in 1926. The curriculum included reading, writing, math, history, and English. Religion and Polish history were taught in Polish. Public educators complained that bilingual curricula hindered students' progress towards assimilation into American society. But dedication made up for much of what the physical plants lacked. (Courtesy of Calumet Regional Archives.)

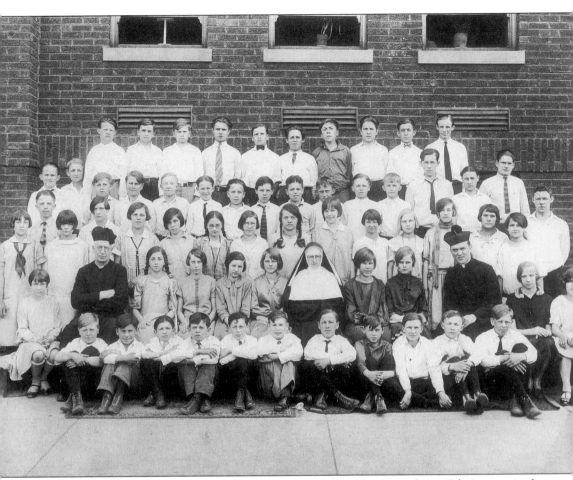

Students pose for a class picture with their teacher and parish priests along 17th Avenue in the early 1920s. In those days discipline was maintained, and those who behaved badly in school rarely complained at home for fear of a second punishment. Parents generally supported the teacher. (Courtesy of St. Hedwig.)

# *Four*

# 1931–1941

## CO MNIE *DZIS*, *TO TOBIE JUTRO*
### (WHAT HAPPENS TO ME TODAY, MAY BEFALL YOU TOMORROW)

In the pre-plastic years before World War II, Americans paid their bills in cash on payday. In Gary, every other Monday was a "red letter day." Rent, food bills, clothes, and saloon accounts were paid. Christmas, it was said, came 26 times a year in the Steel City. Stores were busy, local taverns crowded and profitable.

But as the 1920s waned, many worried about the economy. But most Americans happily let the good times roll, at least, until Tuesday, October 29, 1929, when stock market imploded, ushering in a lengthy decline that finally devastated the economy. At first the "experts" dismissed the events on Wall Street as temporary or even "to be expected," and awaited the next boom.

Following the year-end slow down in 1929, the Gary Works operated at 90 percent capacity through January 1930, despite the panic spreading across America. Smoke, and therefore prosperity, still was visible. U.S. Steel common stock climbed to 175 at the close of the month. At the Gary Works, construction workers were building new facilities, while other steel companies sought new plant sites in the region. Poles, like their fellow immigrants, had worked hard for a better life, and by 1930, most owned their own homes. Some even became landlords.

Amid the growing desperation of 1931, the city fathers wondered how to pay for a celebration of Gary's Silver Jubilee. U.S. Steel was then operating at 40 percent capacity, thousands were unemployed, and the future seemed grim. And far worse was coming; by 1933 the Gary Works was limping along at 10 percent of capacity, and every local business, large and small, was in distress. Local banks toppled early. By the end of 1930 the Miller Bank, Mid-City Bank, and Fifth Avenue Bank were shuttered, and the president of the American State Bank had committed suicide. By 1933 the Depression had broken every other bank in the city except the Gary State Bank. Even the larger building and loan societies had to close their doors.

In the early years under Father Swiatkowski, St. Hedwig's Parish faced financial ruin. Families were simply unable to support the church. The contents of the Sunday collection plates were as thin as local pay envelopes. In 1931, St. Hedwig Parish then had the handsome sum of $20,519.53 in its account at the Albert Wachowski Building and Loan Association, earmarked for construction of a new church. But Wachowski failed, and the deposits were frozen. Only a fraction of the money was recovered years later.

Heated court hearings began in 1932. Local newspapers gleefully reported that a furious Father Swiatkowski had challenged Wachowski's attorney, Frank Spychalski, to step outside and "put up his dukes." Order was soon restored, but the angry exchanges continued. Attorney Spychalski gleefully placed a cartoon of the priest punching the lawyer in his office window. But the many parishioners who lost their own money in the collapse saw things in a different light. They praised Father Swiatkowski, the fighting defender of his church and flock.

During the Depression years, enrollment dropped by a third in Gary's ten Catholic schools. St. Hedwig's student body fell from 870 in 1931 to 311 in 1940. Families were unable to pay the monthly tuition of 75¢ or less, but offered what they could, and their children were allowed to attend. Food and shelter for the family came first, forcing many in St. Hedwig Parish to send their children to Pulaski School. St. Hedwig and the other parochial schools endured partly because Gary Catholics had emphasized education rather

than splendid churches. During the 1930s, many parishes were unable to pay the teaching sisters' monthly stipend, and, given the times, some pastors felt little obligation to do so. In 1935, St. Hedwig's Superior, Sister Mary Aloysia, asked Mother Mary Antonina, the Superior of the order, to help the long-unpaid sisters at St. Hedwig. Sr. Mary Aloysia had heard that the Bishop of Fort Wayne had signed a contract to cancel the church's debts to the Sisters. Not so, she was informed, there was no such agreement, but there were no stipends either. But the sisters faithfully continued to serve the parish, with neither money nor the promise of any.

Innovative cooks concocted meals of all sorts of leftovers. When the Trafny family went to their little farm near East Gary, Steve, the second oldest son, watched the younger children. Steve worked in a local meatpacking house for long hours and short pay. His feet were often wet and swollen from standing on the cutting floor. According to his youngest sister, Veronica, he concocted a stew that included vegetables, leftover meats, spices, herbs, and, most of all, whatever. Steve called it Slumgullion, but whatever it was, it kept the family alive.

When breadwinners lost jobs, money grew scarce, and children suffered. Dixie Dairy of Gary delivered milk to families with small children and told parents to pay later when money came in. Some actually stole milk from the porches until caught by watchful neighbors. Coal furnaces, which graced most homes in Gary, were fed anything that burned. Youngsters lugged coal or coke home from the mills or train-yards. Helpful locomotive engineers and firemen threw a little coal their way; more adventurous teenagers "helped" coal fall off slow freight trains.

Though Polish Americans respected education, economic reality often compelled their children to quit school early and go to work. The father's income, if any, was often not enough. The children's earnings went into the family treasury, to be dispensed by the parents.

Despite monumental setbacks, Father Swiatkowski and his parishioners maintained and even improved the church building. Plans for a new hall were put on hold, but volunteer workers renovated the interior of the church and landscaped the church grounds. Maintaining St. Hedwig was both a community project and a beacon for better times.

The repeal of the 18th Amendment brought few changes in local drinking habits, but at least the taverns were again legal. Tavern owners encouraged their customers to drink and spend more, but unemployment was a much greater source of family fights in the 1930s.

Keeping or finding a job was the central concern of almost everyone. In mid-1933, U.S. Steel reported its first profit in over two years, and ordered a 40-hour week and a minimum wage of 40¢ an hour. But mill officials adopted a "share-the-work" policy designed to help as many families as possible, and few worked more than one or two days a week.

Franklin Roosevelt's popularity animated every ethnic group, but a few still liked the more radical candidates. Though his sister Helen worked for the Democratic Party, Michael Trafny's second son Steve voted Socialist during the 1930s. Steve liked candidates that promised jobs, despite an ongoing family feud. Steve stuck to his guns, arguing, "Hell, people were still out of work."

Polish Americans had converted to the Democratic Party by the mid-1930s. When the great economic collapse occurred, Poles in Gary found their difficult climb towards a decent standard of security and home ownership threatened. Many blamed the Republicans, who had sold themselves as the agents of prosperity. The Lake County Democratic Party was revitalized after 1930, and finally opened its doors to ethnic candidates and voters. The industrial union movement of the 1930s, which enjoyed powerful White House and Congressional support, was a powerful draw for blue-collar families. Some still complained that politicians could be seen only from a distance at social functions, but after 1935 union organizers actually came to the plant gates and talked to people.

As the economy slowly recovered, father Swiatkowski launched more parish renovation and construction projects. The old wooden school was demolished in 1938. The original church, which served as the parish hall in the 1930s, was also demolished, according to Edward Kaminski. Some of the wood was saved and later incorporated in the new auditorium and for classroom partitions on the top floor of the newer school building.

The Great Depression devastated the St. Hedwig community. Countless families in the neighborhood faced long-term unemployment. Young people abruptly left school to find jobs to assist their desperate families. But the St. Hedwig neighborhood survived, and Sister Virginette Rokicki recalled that many at least tried to enjoy life, respect one another, and help their neighbors whenever possible.

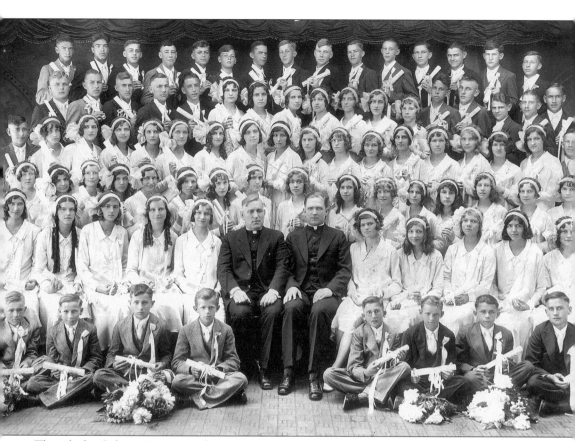

Though the Calumet Region and nation was facing economic disaster, graduation for the Class of 1931 still held the joy of accomplishment. This group was part of the generation of Americans that conquered the Great Depression and World War II. (Courtesy of St. Hedwig.)

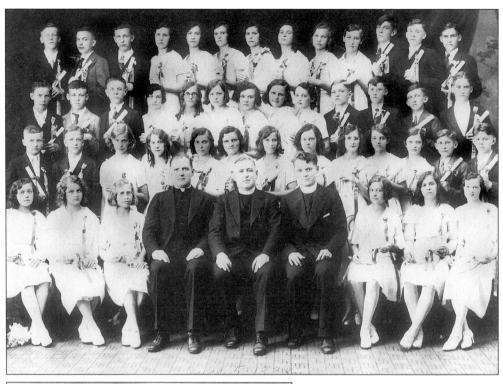

On June 5, 1932, it was graduation day for this group of St. Hedwig students. Due to the hardships of the Great Depression the class was about half the size of the previous year. (Courtesy of Pete Ogiego Family.)

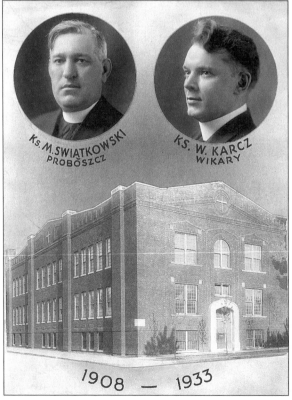

Ks. M. SWIATKOWSKI
PROBÓSZCZ

Ks. W. KARCZ
WIKARY

1908 — 1933

In 1933, St. Hedwig Parish observed its Silver Jubilee. The original design for the front cover of the anniversary booklet featured pictures of Father Swiatkowski and Father Karcz above the church-school building. (Courtesy of St. Hedwig.)

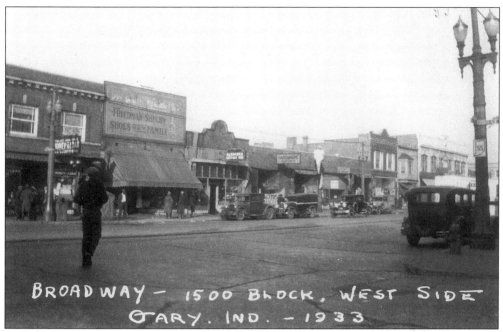

BROADWAY — 1500 BLOCK, WEST SIDE
GARY. IND. — 1933

Pictured here is the west side of the 1500 block of Broadway in 1933—one of the worst economic periods in Gary's history. With the Great Depression far from over, many of the Central District's business establishments kept their doors open. Some extended credit as far as possible to long-time loyal neighborhood customers. (Courtesy of Calumet Regional Archives.)

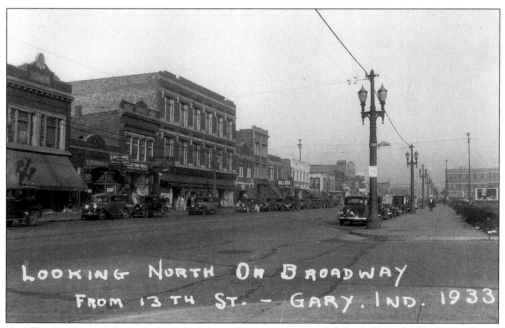

LOOKING NORTH ON BROADWAY
FROM 13TH ST. — GARY. IND. 1933

A different view of the Broadway business district near St. Hedwig in 1933. The camera faced north from 13th Avenue. By the early 1970s, the entire area was leveled on the west side of the street. Today new strip malls have brought new business establishments to the community. (Courtesy of Calumet Regional Archives.)

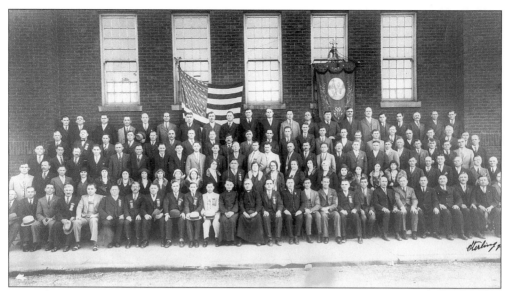

Members of the Holy Trinity Society, Group 337, of the Polish Roman Catholic Union assemble for their organization's picture on the north side of the school. The photo may have been taken for the Silver Jubilee of the parish in 1933. Note fedora hats were popular with the men. (Courtesy of Pete Ogiego Family.)

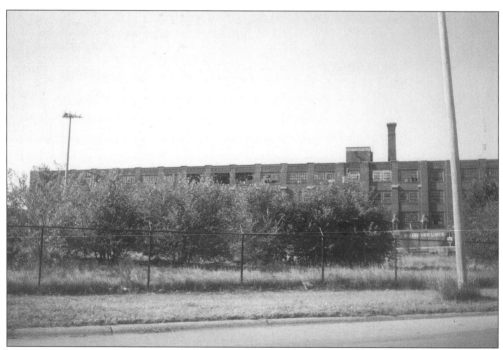

A lifeless, empty structure today, the former Bear Brand brought jobs and hope in 1933. Over one-thousand employees worked there, many from the St. Hedwig community.

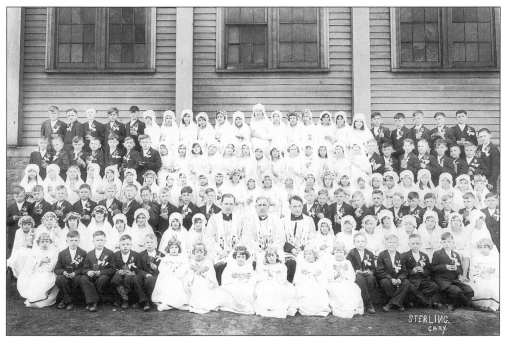

Hard times could wait until tomorrow. The expressions on the faces of the children of this First Communion Class of about 1930 tell a great deal. The economic situation was bleak throughout the nation, but to these children this was a special and joyous day to them and their families. (Courtesy of Chester Dombrowski.)

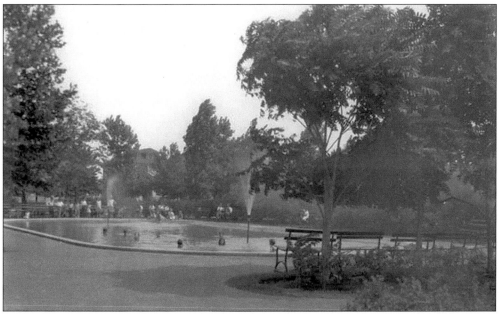

Washington Park, on East 15th Avenue, provided families from the St. Hedwig neighborhood temporary relief from the hard times and usual summer heat. People could swim, watch or play ball, or just plain relax. The picture is from the summer of 1934. (Courtesy of Calumet Regional Archives.)

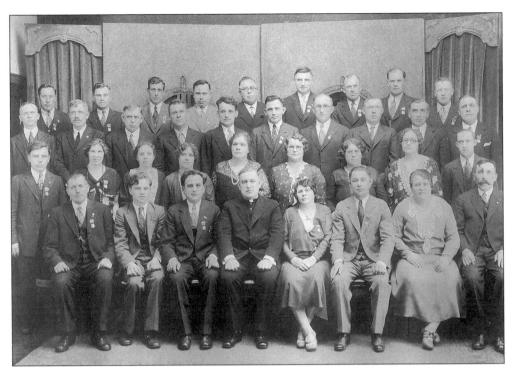

Fraternal groups continued despite the hardships of the Great Depression. The two groups were from the Polish National Alliance. Both photos were probably part of the Silver Jubilee booklet that St. Hedwig printed in 1933. (Courtesy of Dennis Noskoskie.)

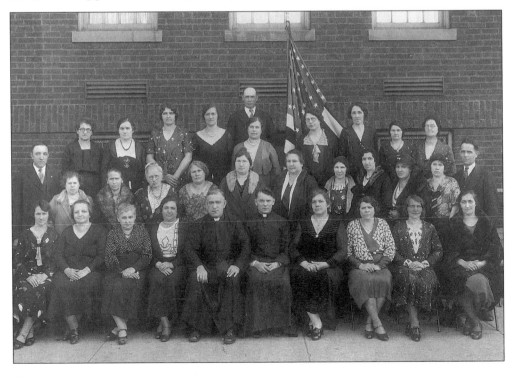

Young men who could not find employment in the Steel City had to look to openings with the W.P.A. or the Civilian Conservation Corps. With the C.C.C. men planted trees, cleaned rivers, and built fire trails. They received $30 a month, $25 of which were sent home. Here John Trafny relaxes after a long day's work. (Courtesy of Dolly Trafny.)

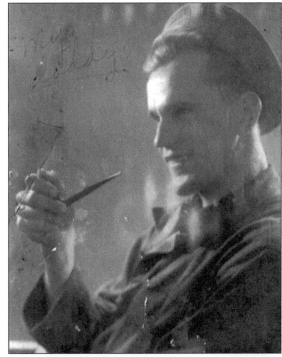

There were many occasions to celebrate during the Depression. In 1935, Anna Gajewska married Frank Kersten at St. Hedwig Church. (Courtesy of Calumet Regional Archives.)

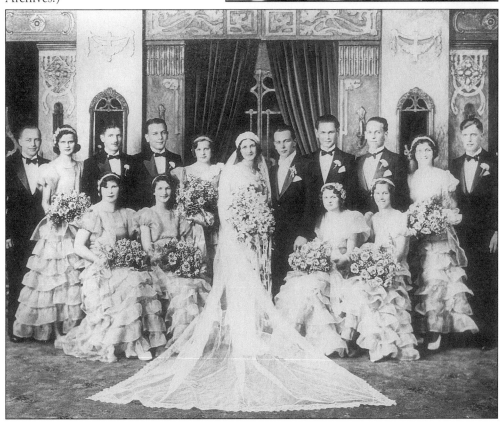

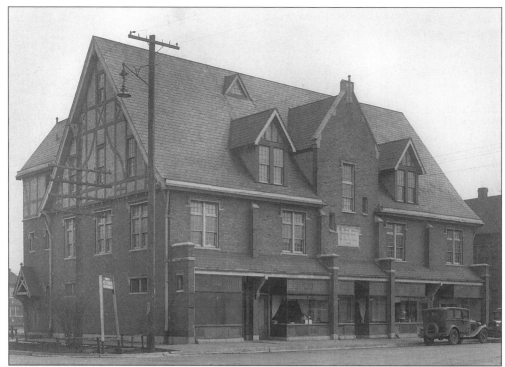

In 1924, the John Stewart Memorial Settlement House was constructed on 15th Avenue and Massachusetts Street. It was established through the efforts of the Rev. Frank S. Delaney. During the 1930s, food and shelter was provided there for African Americans of the Steel City in need of assistance. (Courtesy of Calumet Regional Archives.)

The Froebel High School Bank on stage in 1936. Many graduates of St. Hedwig went on the study at the Central District School. (Courtesy of Henry Lisek.)

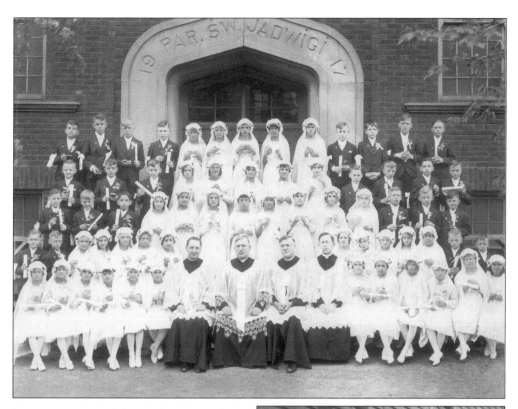

It was a very special day in the spring of
1936. The 3rd graders of St. Hedwig
School received the First Holy
Communion. With the youngsters are the
Rev. Michael Swiatkowski and his
assistants. Behind them is the church and
school building that was constructed in
1917. (Courtesy of St. Hedwig.)

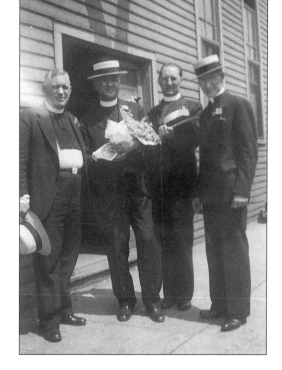

A little break is always good for the soul.
Pictured, from left to right, are: Rev.
Michael Swiatkowski, Rev. Louis
Ratajczak, Rev. Wencel Karp, and Rev.
Louis Madejczyk. The group was outside
the White Eagle Hall on August 8, 1936.
(Courtesy of St. Hedwig.)

45

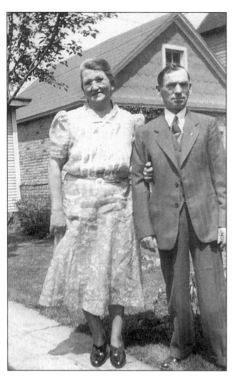

Martin Gajewski and Cecylia Smurczynska came to America in 1907 after a 14-day journey on the *Bremen*. They were married in 1909 and raised 10 children. Here they pose in front of their home at 1528 Maryland Street in the late 1930s. (Courtesy of Calumet Regional Archives.)

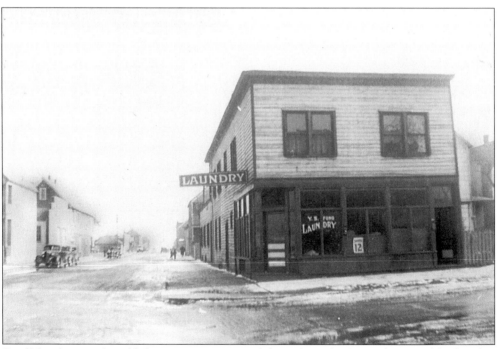

Small family-owned establishments were scattered throughout the St. Hedwig neighborhood in the late 1930s. They stayed in business despite the severe economic downturn of the decade. The view is from the intersection of 17th Avenue and Delaware, looking east. The 12¢ price in the window would be a great bargain today. (Courtesy of Calumet Regional Archives.)

Father Louis Madejczyk and John Labus pose outside the school building in February of 1939. Mr. Labus served St. Hedwig Parish as caretaker during the 1930s. (Courtesy of Jane Juzinal.)

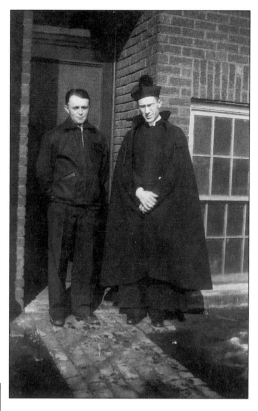

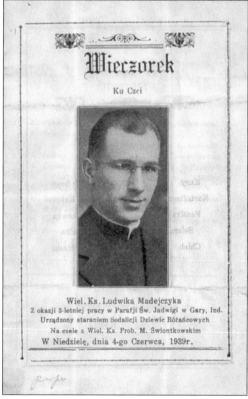

On June 4, 1939, St. Hedwig Parish honored Louis Madejczyk with a special banquet. The front cover of the program booklet, in Polish, is shown. (Courtesy of St. Hedwig.)

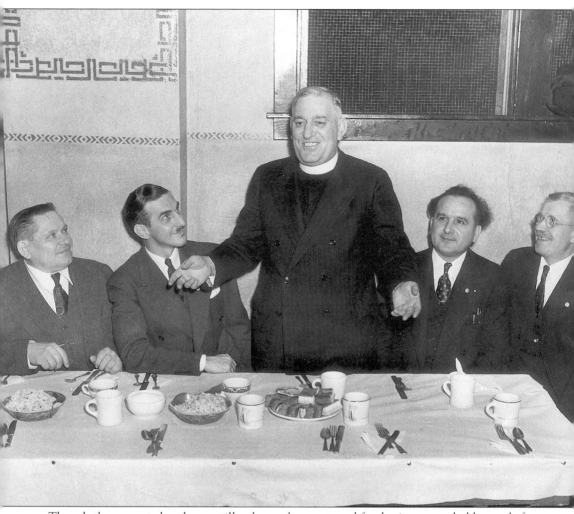

Though the present church was still a dream, banquets and fund-raisers were held years before the ground was broken. In October of 1939, the Rev. Michael Swiatkowski gave a dinner crowd the latest news concerning church construction. (Courtesy of Lillian D. Madenow.)

# Five
# 1941–1945

## A STATE OF WAR EXISTS...
### (F.D.R. DEC. 8, 1941)

At dawn on September 1, 1939, war returned to Europe. German tank and infantry units drove deeply into western Poland, while bombers and fighters hit key Polish targets. Poland's small air force was overwhelmed, and the defending armies along the German border were either captured or retreated in confusion. Polish Americans were shocked by the speed and brutality of the attack and fearful for family and friends in Poland. Gary's Polish community reacted with disbelief and outrage. Prayers and rosaries were offered for Poland and the victims of the new war. Families desperately tried to contact loved ones across the Atlantic. A few young men tried to volunteer to fight for Poland.

A Polish defense fund was organized in Gary one day after the German assault began. Part of a general movement by Polish Americans, representatives of 11 units of the Polish National Alliance began a subscription campaign at Polish Hall at 21 East 17th Avenue. The Central Committee of the P.N.A. sent $7,600 to the Polish ambassador in Washington for war supplies. But the Warsaw government fell to the Germans within three weeks, and the money was probably diverted to the Free Polish Forces. Early in September of 1939, Dr. Alexander Ritter, the editor-in-chief of the Polish Medical Press, came to Gary to announce that the German war machine was overextended, and that Poland had not yet begun to fight. Quite unaware of European realities, Ritter, the guest of Dr. D.L.J. Danieleski, was valiantly trying to rally support for a lost cause.

But in an astonishing sermon delivered shortly after the German invasion, Father Michael Swiatkowski advised St. Hedwig churchgoers that Poland had been attacked, indeed, punished, for not praying enough. Enraged, many parishioners immediately left the service, some never to return.

The vast majority of Gary's Poles were Roman Catholic communicants at St. Hedwig, Sacred Heart in Tolleston, or Holy Family Church in Glen Park. But some, including a number of St. Hedwig parishioners still enraged at Fr. Swiatkowski's attack on the Polish nation, became members of Divine Providence Polish National Catholic Church. Founded in Scranton, Pennsylvania, the National Church called for greater autonomy and congregational control of church properties. Many of its members believed that the Roman Catholic Church had neglected Polish immigrants. Gary's Polish National Church was organized in 1939 and within three years, had attracted 165 families.

On December 7, 1941, the war came to America. The Japanese attack on Hawaii was an unforgettable experience for Steve Trafny of the 24th Division. Then stationed at Schofied Barracks in Hawaii, Trafny was scheduled to return to the Mainland in a few weeks. Instead he was caught by surprise by strafing Japanese fighters on his way to the mess hall. Trafny joined the war armed with a .45 pistol and *three* rounds. He was told that two were for the enemy, and one for himself, since it was better not to be taken prisoner.

For those in uniform like Steve Trafny and Frank Dzienslaw, the future was unclear. They were in the army "for the duration." St. Hedwig's young men volunteered for the armed forces en masse within a few days of the official declaration of war. Faced with a backlog at the enlistment center, many joined

National Guard units in Indiana and elsewhere. Some, like Frank Bentley, decided not to wait to marry. Bentley married his sweetheart Magdalin in St. Hedwig Church early in 1942, then went to war.

Helen Trafny Lis, a lifelong member of St. Hedwig Church, recalled that all her brothers except the eldest served in the battle zones during World War II. John, the youngest, fought in North Africa and later, Italy. Billy stormed ashore at Omaha Beach on D-Day, and, with Stanley, later fought in the Battle of the Bulge. Steve fought in New Guinea and later in the invasion of the Philippines. All survived the war.

Families in the St. Hedwig neighborhood hung flags in their living room windows displaying one blue star for each family member in service. A gold star indicated the supreme sacrifice. Two parish families had three sons in the military. The Nawrocki and Gajewski sons all served in the U.S. Army, and the Trafny home displayed four stars in the front window. While serving in the jungles of New Guinea, Gary native and army dentist Captain Theodore W. Tolpa cleverly replaced the foot pedal on his field-model dental drill with a pulley-motor-battery arrangement. Meanwhile, brother Edward A. Tolpa served on the aircraft carrier, *U.S.S. Wasp.*

Gary was considered high on Hitler's target list because of the steel mills, and so, in the early years of the war, blackout drills were conducted regularly. Sirens signaled the beginning and end of each, and on one occasion, clouds of smoke poured from smokestacks to cover the mills to confuse possible enemy bombers. Fortunately, the enemy had no fleets of long-range bombers that could reach either coast, let alone the Midwest.

Even in wartime, people found ways to enjoy themselves. Many went to movies at the nearby Palace Theater, attended dances at church and local halls, or just visited friends. Kids listened to radio broadcasts of westerns, the latest adventures of the Shadow and Superman (and wondered why Superman didn't use his superpowers to polish off Hitler and Tojo). Dance halls were always busy. The few young men still at home who could dance often went home with sore feet because of their noble contribution to the home front.

The daily life of St. Hedwig's Polish Americans changed dramatically during the war years. Like women in other ethnic groups, Polish women worked in the mills and factories. Children were often home alone after school. A few servicemen died in combat, some were disabled, but most came home whole. Families broke up under the pressures of time and distance. Community and family cooperation helped many through the crisis.

The war ended in stages during 1945. For the Polish Americans of Gary it meant home, family, and a new beginning. The parishioners of St. Hedwig attended Masses of Thanksgiving on V-E Day and V-J Day, mourned those who did not return and welcomed home veterans who had given years to the service of their country.

## St. Hedwig Parishioners who gave their lives in military service during World War II

| | |
|---|---|
| *Joseph Borysiewicz* | *John Grabos* |
| *Walter Lawandowski* | *Henry Dombrowski* |
| *Ben Grochowski* | *Walter Machielak* |
| *Peter Dombrowski* | *Stanley Kwilasz* |
| *John Pienta* | |

In 1941, the Rev. George Dubowski celebrated his first mass at St. Hedwig Church. To his right are his parents and the Rev. Michael Swiatkowski. For many years, Father Dubowski served the Church by doing missionary work in the Philippines and Southeast Asia. (Courtesy of Calumet Regional Archives.)

Divine Providence, Polish National Church was located on 15th Avenue and Maryland Street. The parish was organized in 1939, and attracted many Central District Polish families. Today the parish is located on West 57th Avenue in Merrillville.

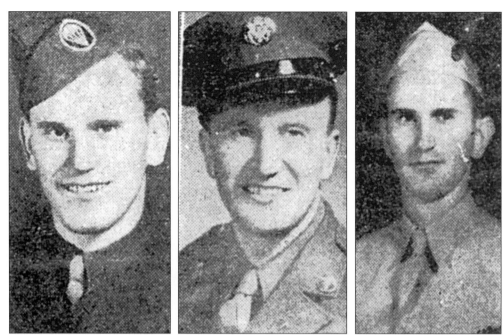

To keep the community informed of local servicemen during the war, local newspapers featured daily stories of their exploits. Pictured are three of the four Trafny brothers who fought in both theaters of the greatest conflict in the history of the world. (Courtesy of John Peck.)

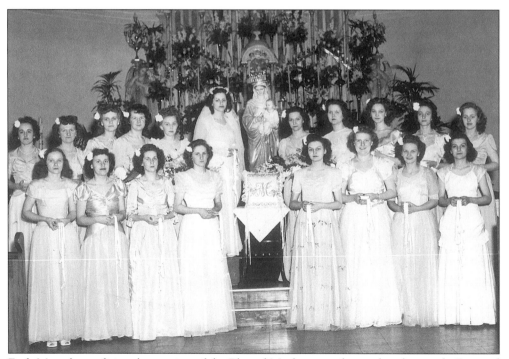

Each May, the traditional crowning of the Blessed Mother was observed at the parish. Pictured are the young ladies of the St. Hedwig Sodality group in the early 1940s. The event took on added importance as the nation was involved in World War II. (Courtesy of Evelyn Lisek.)

Eddie Tolpa was already in the United States Navy before the nation's entry into World War II. He served in the South Pacific aboard the *U.S.S. Wasp*. In 1942, he survived a brutal sea battle that claimed his ship and many comrades. He is pictured here with his wife Donna during the last months of peace. (Courtesy of Evelyn Lisek.)

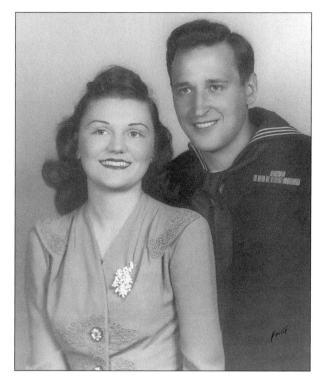

Dr. Theodore W. Tolpa served in the jungles of New Guinea and later took part in the invasion of the Philippines. While aboard a slow-moving *Liberty* ship in the Leyte Gulf, Dr. Tolpa helped army doctor R.A. Robinson carry out an emergency appendectomy on a young Australian flier. After the war, he was a successful dentist in the Steel City. (Courtesy of Evelyn Lisek.)

53

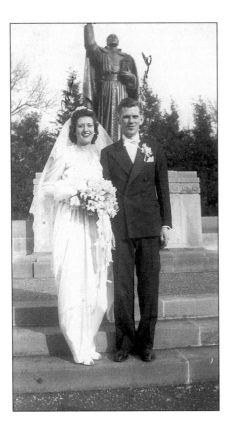

Frank and Magdalin Bentley pose before the statue of Father Marquette in Gary on January 17, 1942, a few weeks after Pearl Harbor. (Courtesy of Larry Bentley.)

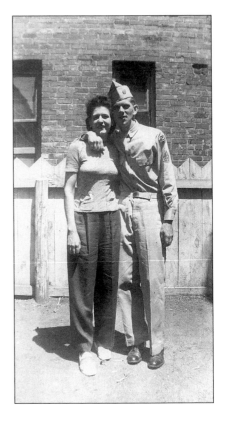

A year later, Cpl. Frank Bentley and Magdalin together in the neighborhood. Their time together was brief as the young corporal was getting ready to be shipped off to his duty station. (Courtesy of Larry Bentley.)

Frank Denslaw was already in the military when hostilities began in 1941. Here he is shown in 1943 bearing "gifts" for the Axis armies. Friends called him "Machine Gun Kelley." (Courtesy of Helen Dzienslaw.)

St. Hedwig's First Communion Class of 1943 poses for a group picture by the school building. First graders served as escorts for the 3rd graders receiving the sacrament of Holy Communion that day. (Courtesy of Rosemary Malocha.)

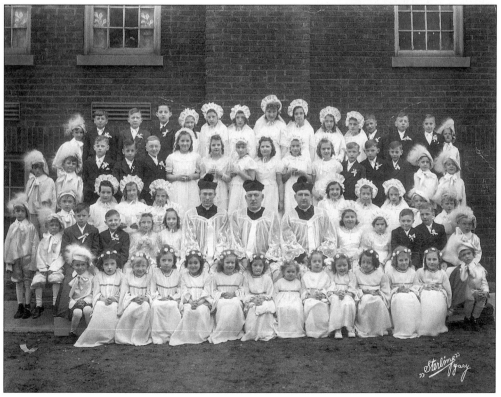

On the northwest corner of 17th Avenue and Pennsylvania Street was Lottie's Department Store. It was owned and operated by Walter and Sophie Kolodziej. The business is pictured here in the early 1940s. (Courtesy of Rosemary Malocha.)

Daughter Rosemary Kolodziej outside of the family business in the early 1940s. The building in the background is Matt's Tavern at 16th and Pennsylvania Street. (Courtesy of Rosemary Malocha.)

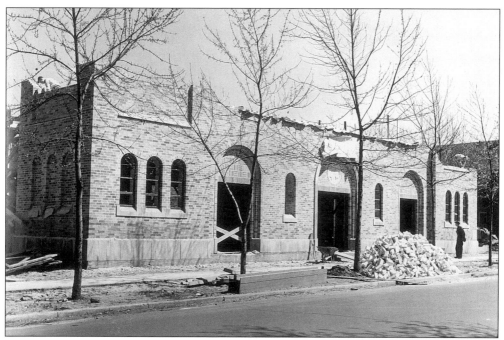

In 1940, the cornerstone of the present St. Hedwig was laid. Construction continued during the war years despite shortages of steel and other materials. Here, the lower portion of the structure at the main entrance is nearly complete. Most of the work would be completed by September of 1942. (Courtesy of St. Hedwig.)

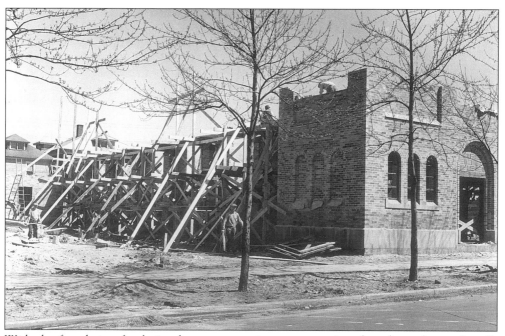

With the foundation firmly in place, construction crews continued work on the north wall. Wooden beams were set in place to give the brick and stone additional support. (Courtesy of St. Hedwig.)

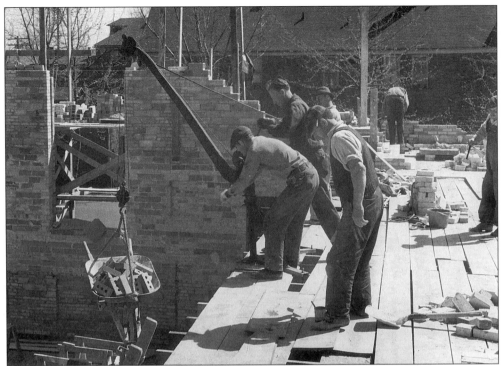

Stonemasons are skilled craftsmen, but their line of work can put a strain on the back. Here workers use a small derrick to raise a load of brick onto the work platform. The view is of the interior south wall to the left and the south bell tower to the right. (Courtesy of St. Hedwig Parish.)

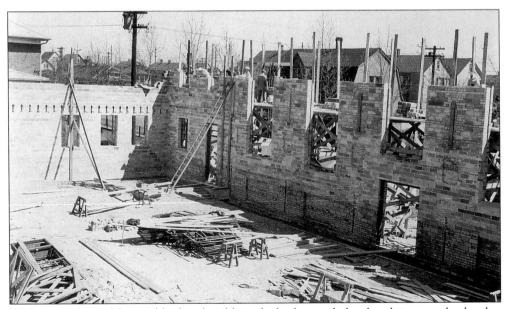

With the rooftops of the neighborhood visible in the background, the church interior slowly takes form. The view is of the southwest section of the building where the priest's sacristy is to be. (Courtesy of St. Hedwig.)

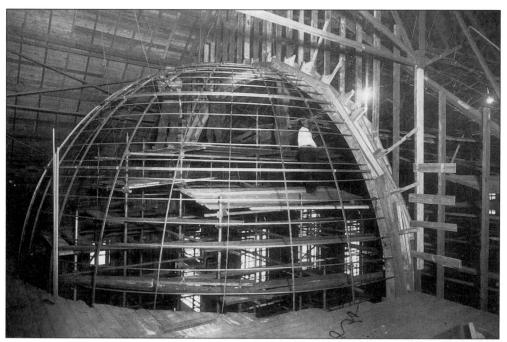

With the outside of the church building nearly complete, work shifts to the interior. Here workers connect support cables for the steel rods, which will be the frame for the dome above the main altar. (Courtesy of St. Hedwig.)

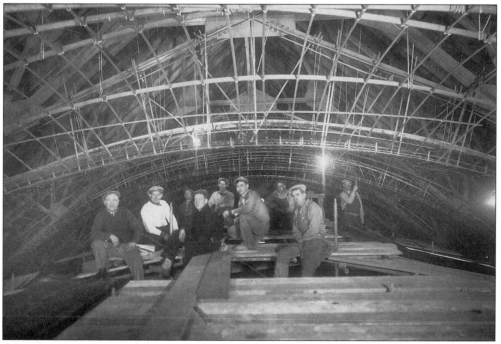

After the main section of the roof was completed, workers focused their attention to maze of support beams and steel rods that held the ceiling and lighting. Here workers take a 5-minute break to pose for a picture. (Courtesy of St. Hedwig.)

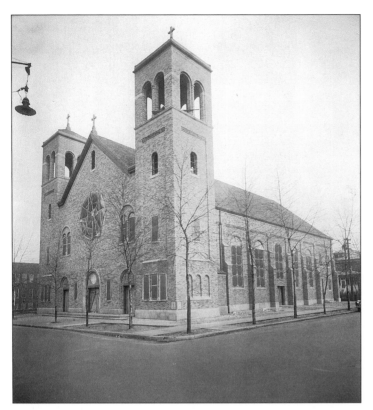

To the left is a nearly finished St. Hedwig Church as viewed from the intersection of 18th Avenue and Connecticut Street. On close inspection it can be seen that the stained-glass windows, the rose window above the main entrance, and doors were not yet installed. (Courtesy of St. Hedwig.)

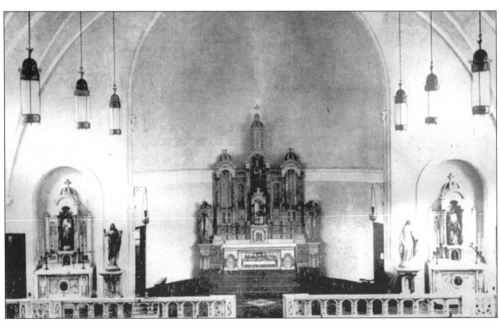

On September 20, 1942, His Excellency, Bishop John Francis Noll, dedicated St. Hedwig Church. The beautiful artwork above the alter, the walls, and ceiling would not be completed until about 1947. (Courtesy of St. Hedwig.)

Unit 48 of the World War II Mothers sponsored the building of a memorial structure to the young men who served the nation during the war. Here Father Swiatkowski looks at the finished monument. (Courtesy of St. Hedwig.)

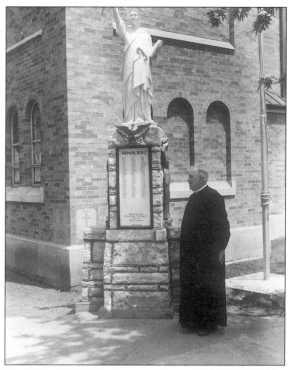

Though the nation was in the midst of a terrible war, there were times to share in the joy of accomplishment and the dreams of a better future. Here the members of the 8th grade graduating class and the parish priests pose for the group picture in front of the newly completed church in 1943. (Courtesy of St. Hedwig.)

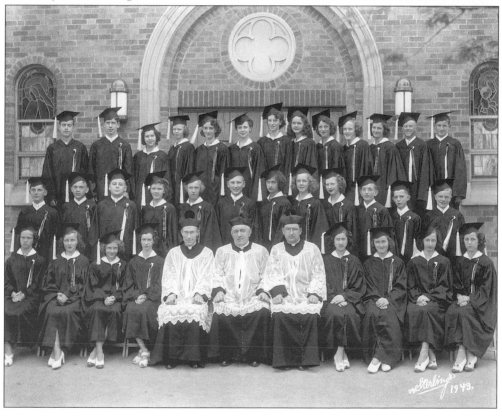

# FORMER MOTHER SUPERIORS OF
# ST. HEDWIG SCHOOL (1909–1978)

| | | |
|---|---|---|
| 1909–1910 | Sister M. Jerome Dadej | Superior/Principal |
| 1910–1911 | Sister Mary Welter | Superior/Principal |
| 1911–1912 | Sister M. Susanna Kielpinski | Superior/Principal |
| 1912–1915 | Sister M. Humilianna Lemanczyk | Superior/Principal |
| 1915–1917 | Sister M. Bernice Stefanski | Superior/Principal |
| 1917–1918 | Sister M. Benedict Polcyn | Superior/Principal |
| 1918–1921 | Sister M. Eugenia Detlaf | Superior/Principal |
| 1921–1924 | Sister M. Wenceslaus Gorski | Superior/Principal |
| 1924–1931 | Sister M. Zita Kosmala | Superior/Principal |
| 1931–1932 | Sister M. Paul Kirschbaum | Superior/Principal |
| 1932–1937 | Sister M. Felicita Pajor | Superior/Principal |
| 1937–1943 | Sister M. Zita Kosmala | Superior/Principal |
| 1943–1946 | Sister M. Eustace Borowski | Superior/Principal |
| 1946–1952 | Sister M. Zita Kosmala | Superior/Principal |
| 1952–1955 | Sister M. Euphemia Switalski | Superior/Principal |
| 1955–1961 | Sister M. Carmel Rokicki | Superior/Principal |
| 1961–1964 | Sister M. Hermenegilde Moszczynski | Superior/Principal |
| 1964–1966 | Sister M. Edward Nowak | Superior/Principal |
| 1966–1970 | Sister M. Rosaline Lenart | Superior/Principal |
| 1970–1972 | Sister M. Equita Nawracaj | Superior/Principal |
| 1972–1973 | Sister M. Equitia Nawracaj | Principal |
| | Sister M. Claudina Jachimowicz | *Superior |
| 1973–1974 | Sister M. Claudinia Jachimowicz | Superior |
| 1974–1978 | Sister M. Louse Nowicki | Superior |

*In 1973, Mrs. Bernice Tanner Richardson was appointed the first lay principal at St. Hedwig School

# Six
# 1946–1957

## "SERCE TAM ROSNIE, GDZIE SA ZGODNE GOSCIE"
### ("THE HEART SWELLS, WHERE PEACE REIGNS")

During 1945 and 1946, the veterans returned to communities all over the United States, and the St. Hedwig neighborhood extended a hearty welcome to all. Emotional reunions with families and friends were followed by a time of rest and recuperation. A few vets faced a difficult readjustment to peacetime, but for most, their prewar jobs were waiting. A housing shortage irritated many returning servicemen, especially family men. The young and single, as before the war, lived at home. "Rosie" was released from mill and factory; she either returned to her prewar job (at much lower wages) or married and became a homemaker.

Once jobs and homes were found, Polish Americans entered an era of prosperity and opportunity that brought them to better houses in the cities or southward to the booming collar towns. A new and much better family home was the chief—and usually fulfilled—goal of that generation. For the first time they found themselves in a sea of young suburban families with many origins, and their new parishes reflected that reality.

Older, "ethnic" parishes like St. Hedwig suddenly faced the problem of survival. Migration from the old country had dwindled since the immigration barriers had risen in the 1920s, and many ethnic and urban churches peaked in membership in the 1930s. Polish pastors pondered how to keep the young people of the very different and thoroughly Americanized second and third generation in the churches of their forefathers. To them, the old neighborhood offered little to compare with the trees, fresh air, and sparkling-new "ranches" and "split-levels" in Glen Park and beyond.

Despite the outward migration and other pressures, St. Hedwig Parish membership remained stable well into the 1950s. Many of those who had moved to Glen Park chose to remain with the old parish. On Sunday mornings they either drove or took the bus to St. Hedwig. Enrollment at the parish school hovered above 300 students, but never regained the larger numbers of the 1920s.

Now the third resident pastor of St. Hedwig Church, Rev. Michalski faced the major challenge of maintaining and preserving four aging parish buildings. A sensible man, Fr. Michalski understood that his parishioners had many personal expenses. His policy was to plainly explain the needs of the parish, and ask those who could to set aside a few extra dollars. The response was usually favorable, and parishioners and local businessmen often gave more than was asked. Fr. Michalski, a bit of a financial wizard, was able to repaint the interior of the church, thoroughly recondition the school building, and refresh the convent and the rectory.

Between 1948 and 1953, Congress enacted several laws that admitted up to 400,000 European refugees to the United States. These laws, the first of their kind, represented a commitment by the United States to help those fleeing Communism. For Poles, the Displaced Persons Act offered a new beginning, and thousands joined established ethnic communities in Chicago and the Calumet Region.

The new arrivals hardly resembled Gary's first Polish settlers either economically or socially. Few had come voluntarily, but they had come to stay. Most thought Stalinist oppression in Poland would not end anytime soon. Many were white-collar workers, businessmen, and professionals with college degrees and cosmopolitan views. The older group had been mostly single males, but the new immigrants arrived in

family groups, eager to assimilate into the general population. They won American citizenship in timely fashion, and joined American organizations, among them the local Democratic Party. Many settled outside St. Hedwig Parish and its neighborhood. Raw mill hands soon became skilled craftsmen. Parents and children alike avidly pursued education.

Assisted by Bishop John Noll, Polish Carmelites also settled in the Calumet Region during the postwar period. The Carmelite Order had flourished prior to 1939. During the war many were interned by the Germans or Russians, while others left Poland and joined the Allies. The first five arrived in 1946, still in battle-dress, to establish a mission home.

## DIFFICULT JOURNEY

*The journey to America was not easy. George Witowski (Frank B. Roman) was an American citizen (his parents had come to America in 1910) and a Holy Cross brother working in Poland when the war broke out. Imprisoned by the Soviets in 1939, he was allowed to return to the United States in 1940. Others were less fortunate. Polish soldier Lucian Markiewicz was held in a German P.O.W. camp from 1939 to 1945. Taken by the Gestapo, Bogdan Pankiw was a slave laborer for five years.*

As veterans raised families and new immigrants began their lives anew, one St. Hedwig graduate caught the nation's attention. As a teenager, Anthony Florian Zalewski followed his older brothers into boxing. Young Zalewski won four City Golden Gloves Titles, and by the age of 21, had fought in over 200 bouts. As Tony Zale, he made a less-than-successful professional debut in 1935 as a middleweight. Determined to toughen his body, he shoveled ore, poured slag, and lifted beams at the Gary Works.

During the war, Zale served as a physical education instructor in the U.S. Navy. Probably his skills deteriorated, as he refused to fight recruits. After the war he won great fame in three bouts with Rocky Graziano. Their first battle took place in Yankee Stadium on September 27, 1946. Wobbly in the early rounds, Zale came back to win with a knockout in the sixth. Thirty thousand welcomed Tony Zale at his homecoming to Gary, and he was presented with the key to the city. In the return match Graziano won with a disputed T.K.O in the sixth round, but in the third and final meeting, Zale floored Graziano in the third round to regain his title. The "Man of Steel" was the pride of St. Hedwig and the city of Gary.

The Calumet Region did not neglect Polish language and culture. Gary's *Polonia* listened closely to a weekly Polish Language Program, first aired over radio station WWCA on the morning of January 7, 1950. Chopin's *Polonaise Militaire* was the opening theme. An invocation was delivered by Father Zygmunt Wouciehowski. The program was directed by T. Stanley Kubiak. Lottie (Wladzia) Wawrzyniak (Later Mrs. Chester Kubiak) was the announcer, and Mrs. Helena M. Kubiak selected the musical numbers. Hammond station WJOB carried another Polish-American oriented program hosted by partners Eddie Oskierko and Wally Skibinski.

On July 5, 1950, Father Louis Wozniak became assistant pastor at St. Hedwig Parish. Very popular among younger parishioners and the children of the school, many fondly recalled his great voice and his easy-going personality. Father Louis sang Polish hymns beautifully and delivered thunderous sermons. Certainly he contributed to the success of St. Hedwig Parish Church and School in the early 1950s. Membership remained above 1,400, with some 500 families registered. Drawing on settled Central District families and recent immigrants, school enrollment hovered around 300 students. Both groups wanted their children to receive a Catholic education and learn about Polish culture and traditions.

Christmas, Easter, Lent, and Advent, the major events of the religious year, were closely tied to the Polish-American's social life. Parishioners gathered in St. Hedwig Church to take part in beautiful and dramatic celebrations. Traditional choral music accompanied colorful processions. Some pieces were "modernized" to keep members of the second and third generations interested in their family church, but even they preferred the older ways.

The sacraments and traditions of the Roman Catholic faith deal with every stage of life and death. As elsewhere, the rites of passage at St. Hedwig were Baptism, Communion, Confirmation, Marriage, and finally, death. The church year followed the cycle of the calendar year. Christmas was a family and community event that focused on the birth of Christ. At Easter St. Hedwig celebrated the resurrection of Jesus and the coming of spring. But the style of Polish American religious observances at St. Hedwig was rooted in the customs of rural Poland. The American-born children of immigrants continued many of those traditions.

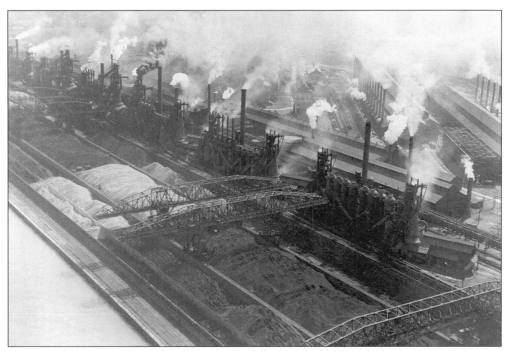

In 1946, the great post-World War II economic boom was underway in the region. Jobs were available for St. Hedwig's returning veterans, as steel was in demand for cars, appliances, and durable goods. Here, all 12 blast furnaces at U.S. Steel's Gary Works were in operation. The red and black smoke in the air meant people were working. (Courtesy of Calumet Regional Archives.)

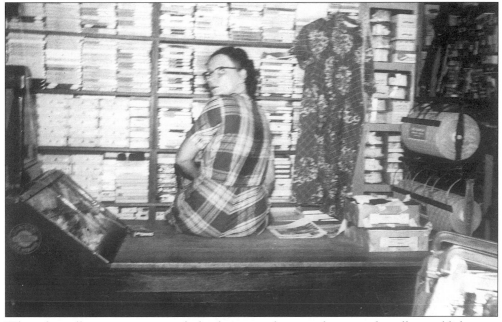

When the mills were running good, the downtown business district and smaller establishments throughout the city of Gary prospered. Here Helen Zielinski takes a break while working at Lottie's Department Store. (Courtesy of Rosemary Malocha.)

Here, Sister Mary Eymard Sanok visits her old neighborhood in the late 1940s. Originally form Footedale, Pennsylvania, Sister Sanok was one of two women from St. Hedwig Parish that entered the Franciscan Order. The other was Sister Francine Labus. (Courtesy of St. Hedwig.)

For the students of St. Hedwig School, recess was always a welcome break from classwork. This 1940s picture should remind many old grads that they were always under the watchful eyes of the good sisters. The building in the background was Nowakoski's Grocery Store. (Courtesy of St. Hedwig.)

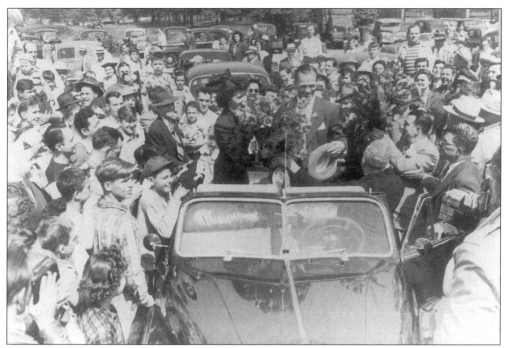

Following his win over Rocky Graziano for the middleweight title, Gary's own Tony Zale returned home to an enthusiastic crowd of over 30,000 on September 28, 1946. On that day Mayor Joseph Finnerty presented the "Man of Steel" with the key to the city. (Courtesy of Calumet Regional Archives.)

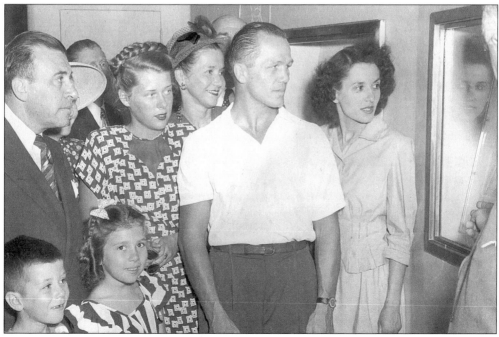

Gary's "Man of Steel" Tony Zale at City Hall. Pictured, from left to right: Mayor Eugene Swartz, Patti Grubbs, Mrs. Swartz, Tony Zale, and Mrs. Zale. (Courtesy of Calumet Regional Archives.)

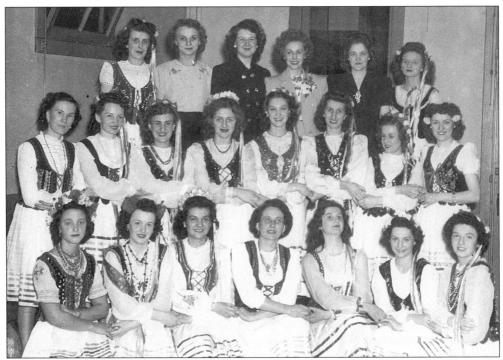

Polish dance and coral groups were popular following World War II. Pictured is the St. Hedwig Polish Dance Group in hand-made traditional ethnic costume. (Courtesy of Evelyn Lisek.)

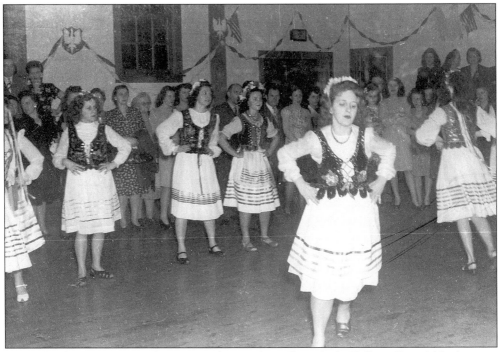

Here, the dance troupe performs a number at the White Eagle Hall on East 16th Avenue. (Courtesy of Evelyn Lisek.)

On October 26, 1947, the bells of St. Hedwig Church were blessed and ready to be installed. Though the church structure was completed in 1942, it was another four years before the bells were ready. This was due, in part, to the wartime steel shortage. (Courtesy of St. Hedwig.)

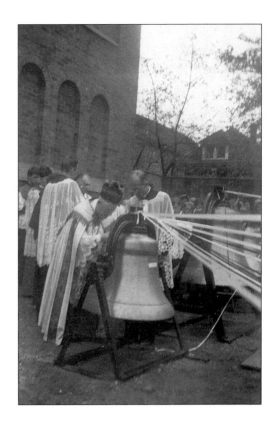

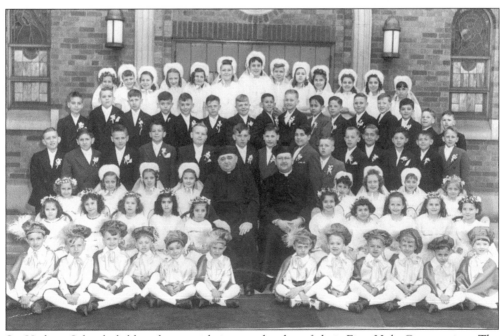

St. Hedwig School children beam with joy on the day of their First Holy Communion. The picture was taken in 1948. (Courtesy of St. Hedwig.)

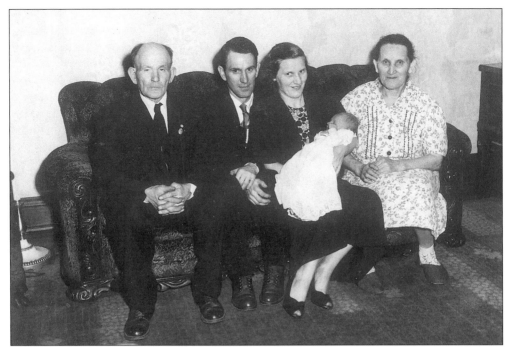

For Steve Trafny, a veteran of the South Pacific and later the American Occupation Forces in West Germany, Christmas 1948 arrived early. On December 22, he went to Midway Airport to meet his Polish-born fiancee, Wanda Wlodarczyk. The couple was married in St. Hedwig Church, and the United States soon became Wanda Trafny's country. Pictured are Steve and Wanda with son John and grandparents Michael and Maryanna. (Courtesy of Wanda Trafny.)

Like many young families after the war, Steve and his wife Wanda lived with the in-laws until housing was available. Pictured is the home Mike Trafny built at 1716 Virginia Street. The home still stands today. (Courtesy of Wanda Trafny.)

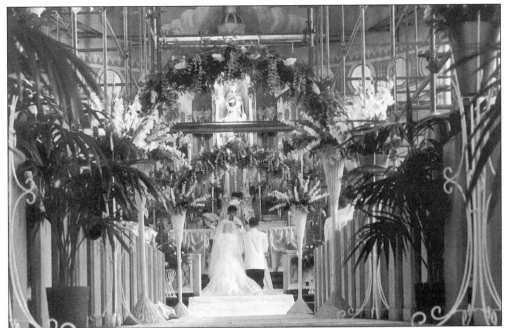

Before the elegant statue of St. Hedwig above the main alter, Henry and Evelyn Lisek take their marriage vows on August 20, 1949. The Rev. Joseph Dziadowicz officated at the ceremony. Note the scaffolding still present. Much of the artwork on the ceiling and walls was not yet completed. (Courtesy of Henry and Evelyn Lisek.)

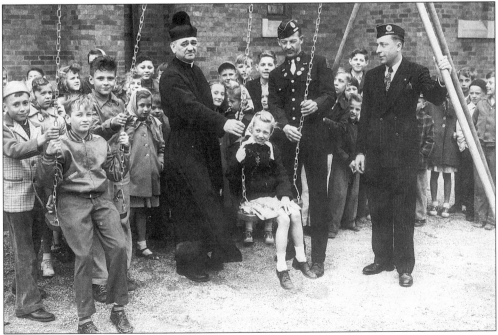

In 1949, the members of Kosciuszko Post 207 donated playground equipment. Here Father Michalski accepts the gift from post commander Leo Mroz and Stanley Kesel. (Courtesy of Henry Lisek.)

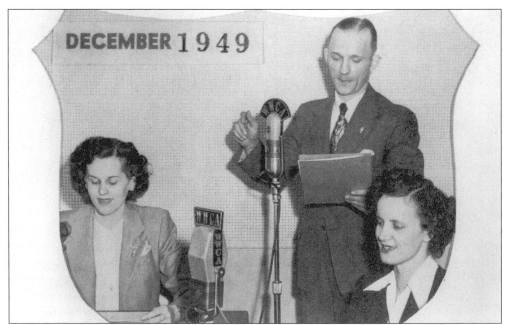

Gary's Polonia listened closely to a weekly Polish Language Program that was first aired over radio station WWCA on the morning of January 7, 1950. Chopin's *Polonaise Militaire* was the opening theme. T. Stanley Kubiak directed the program. Lottia (Wladzia) Wawrzyniak (later Mrs. Chester Kubiak) was announcer, and Mrs. Helena Kubiak selected musical numbers. Following the passing of Stanley Kubiak the show continued until the mid-1990s hosted by Helen Kubiak and Chester and Lottie Kubiak. (Courtesy of Calumet Regional Archives.)

Father Louis Michalski joins Santa at the parish school Christmas party on December 21, 1949. On the last day of school before Christmas vacation, students and faculty always enjoyed a festive holiday gathering. (Courtesy of St. Hedwig.)

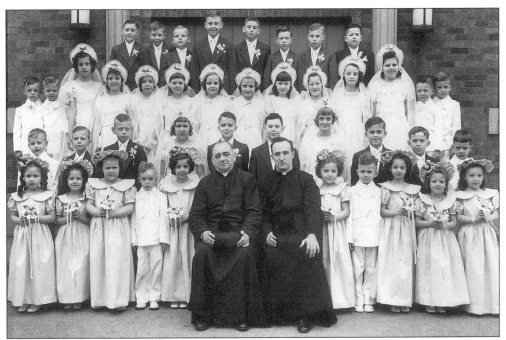

Pictured above is a First Communion class around 1950. Parish children received the sacrament in the 3rd grade. Under the old church rules, one had to fast after midnight to receive the Body of Christ the following morning. First Communion was an important religious experience, and was often accompanied by a gathering of friends and family. (Courtesy of Dennis Noskoskie.)

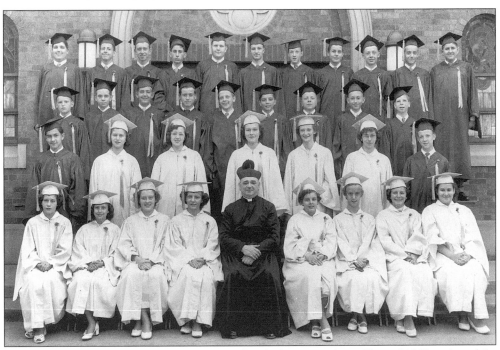

With fond memories and new expectations ahead, the St. Hedwig Class of 1952 gathered for one last time. With them was the Rev. Louise Michalski. (Courtesy of Rosemary Malocha.)

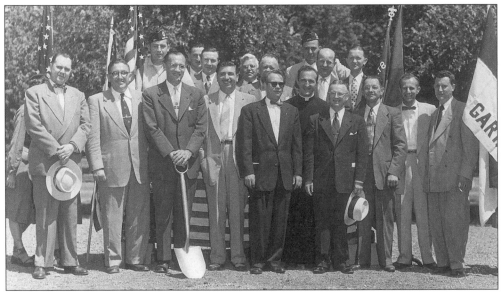

Political figures, scout leaders, and Father Louis Wosniak were all present for the groundbreaking ceremonies for the new scouts' den. The building was built at 15th and Pennsylvania in the early 1950s. (Courtesy of St. Hedwig.)

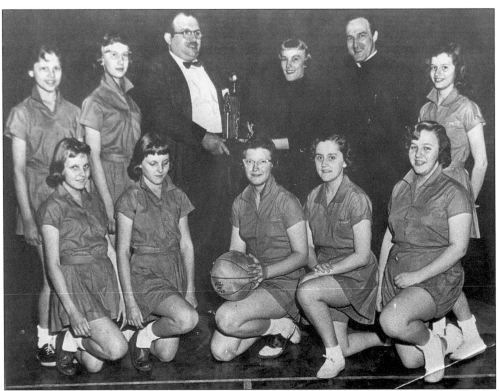

During its heyday, the Gary CYO sponsored athletic events for all of the Catholic grade schools in the Diocese. Here the St. Hedwig girls' basketball team is awarded a trophy during the 1950s. Standing fifth from left is Father Louis Wosniak. (Courtesy of St. Hedwig.)

It's a jump-ball during a St. Hedwig CYO basketball game during the early 1950s. Back then Catholic grade schools in Gary played their games at the Knights of Columbus Hall on West 5th Avenue. (Courtesy of Calumet Regional Archives.)

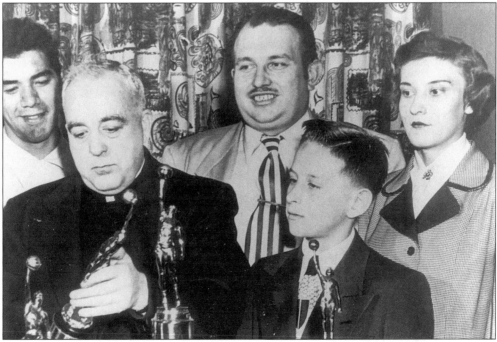

In April of 1953, CYO basketball trophies were awarded. Director, Father Lawrence Grothouse admires the hardware along with Randy Tomsic of St. Anthony Parish. Pictured in the back row are, left to right: James Santalino, Mitchell Nowakowski, and Frances Lelec, all of St. Hedwig. (Courtesy of Calumet Regional Archives.)

Polish culture has always been expressed through song, dance, and literature. It has been kept alive over centuries as one generation passed its excellence to the next. Here St. Hedwig parishioners from the St. Cecilia Choir present a musical concert at Gary's Marquette Park Pavilion in 1953. (Courtesy of John Murida.)

In the 1950s, before the days of supermarkets and mega-markets, Gary's Farmer's Market at 9th and Washington provided fresh goods and served as a place where Poles and other ethnic groups could meet friends and neighbors. The old Konrady sign at the top brings back memories of a time when local firms supplied the fuel for most of the area's heating needs. (Courtesy of Calumet Regional Archives.)

With the post-World War II housing boom underway, many young families from the St. Hedwig community moved to Glen Park and beyond the city's borders. Others purchased homes and two-flats in the old neighborhood. This 1953 photo of the east side of the 1300 block of Pennsylvania presents a typical street near the parish. (Courtesy of Calumet Regional Archives.)

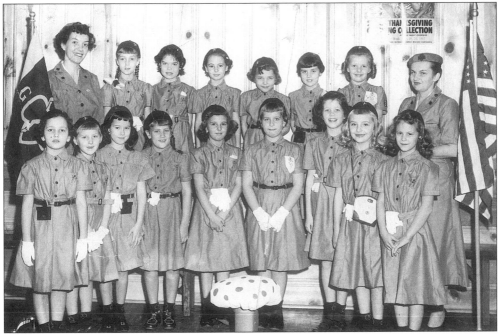

Parish and community organizations were not limited to adult participants in the 1950s. Scouting was open to boys and girls from St. Hedwig. For the youngest girls, the Brownies provided many hours of after-school fun and enduring friendships. (Courtesy of Dennis Noskoskie.)

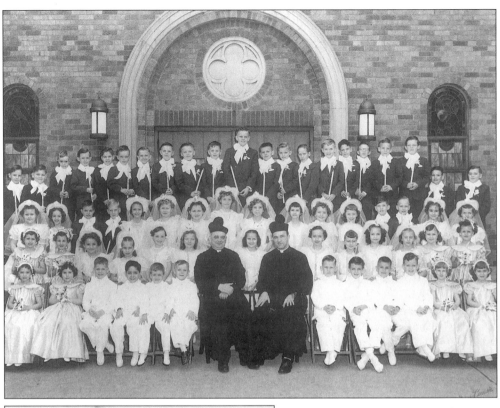

1954

*Roczne Sprawozdanie Finansowe*

z Dochodòw i Rozchodòw

**Parafii Św. Jadwigi**

Gary, Indiana

KOŚCIÓŁ  SZKOŁA

PLEBANIA  DOM SIÓSTR

Ks. LUDWIK MICHALSKI, Proboszcz

Ks. LUDWIK WOZNIAK, Asys.

The First Communion Class of 1954 is photographed with Father Louis Michalski, pastor, and Father Louis Wosniak. Later in the day, hospitality prevailed. Pictures were taken of the communicant with his extended family, and gifts, usually of money, were bestowed on the excited child. Few youngsters objected when a pleased uncle who forgot that he had already contributed to the "fund" provided an extra $20. Many children ended the day with a handsome bankroll. (Courtesy of Dennis Noskoskie.)

Years ago, Catholic parishes throughout the region published copies of their annual financial statements. All parish members were listed along with the total amount of their Sunday contributions. The practice was replaced with letters sent to individual members listing their own annual contributions. A copy of the 1954 booklet is shown. (Courtesy of St. Hedwig.)

The Holy Name Society sponsored the Boy Scout-Father and Son Breakfast in February of 1955. Pictured, from left to right: Norbert Feles, James Bajgrowicz, Stanley Dombrowski, Scout Master Walter Nawrocki, and Walter Majcher. (Courtesy of St. Hedwig.)

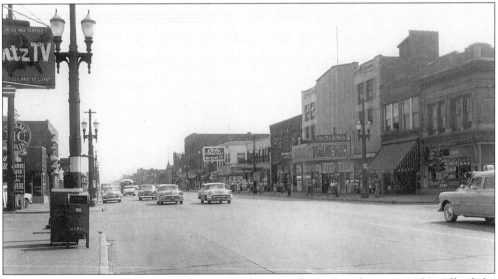

Above is the Mid-town business district, looking south on Broadway in 1956. All of the buildings were leveled during the late 1960s and early 1970s as part of urban renewal. During the 1990s, two strip malls and new housing finally brought new life into the area. (Courtesy of Calumet Regional Archives.)

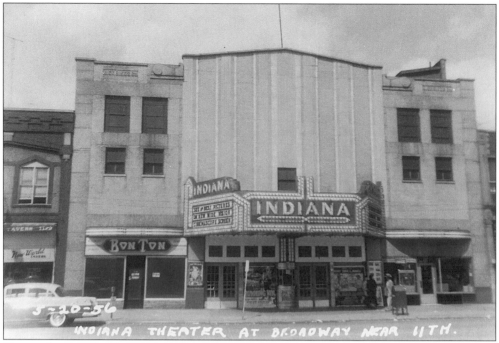

Here is the Indiana Theater in the 1100 block of Broadway in May of 1956. In the days before cable TV and movie rentals people still enjoyed going to see films at local theaters. Besides, few people had air-conditioned homes in the 1950s while movie houses were cool inside. (Courtesy of Calumet Regional Archives.)

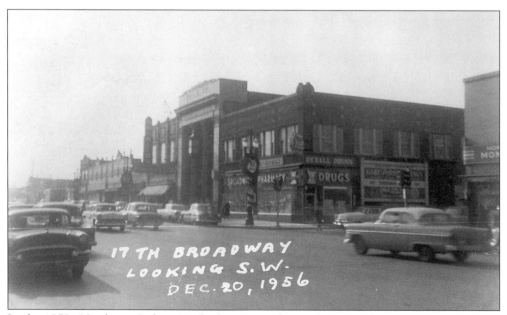

In the 1950s, Northwest Indiana's suburbs were in their infancy and huge malls were nearly a generation away. With the mills booming, the business district near St. Hedwig still claimed a viable economy and a strong customer base. The view is of the southwest corner of 17th and Broadway in December 1956. (Courtesy of Calumet Regional Archives.)

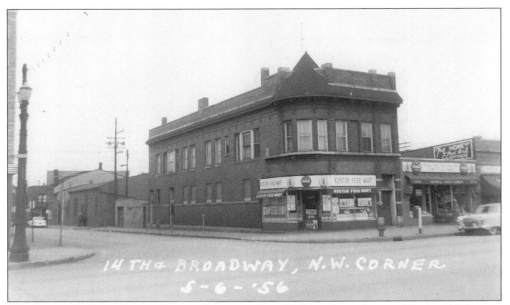

In 1956, corner grocery stores were still a common sight throughout the city. The establishment at the intersection of 14th Avenue and Broadway displayed a classic type of architecture that, sadly, fell to the wrecker's ball in the late 1960s and early 1970s. (Courtesy of Calumet Regional Archives.)

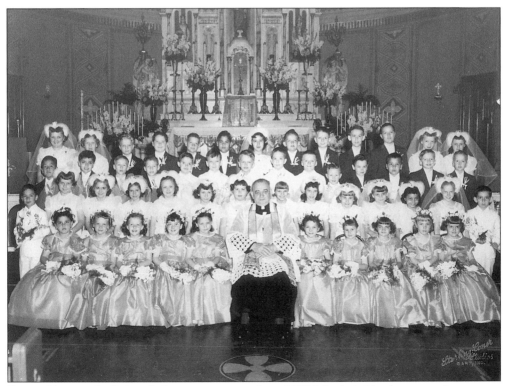

Pictured here is the 3rd grade first communion class of 1956. Included in the group picture were 1st graders who were escorts for the communicants. (Courtesy of St. Hedwig.)

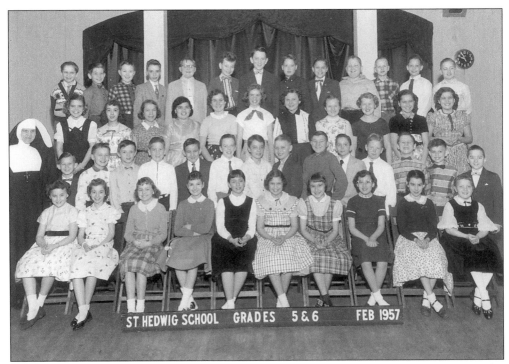

The 5th and 6th graders of Sister Ann Rose Mroz pose for a class picture in 1957. When the school building was constructed in 1917, the upper hall served as the church and the stage behind the students was the main altar.(Courtesy of St. Hedwig.)

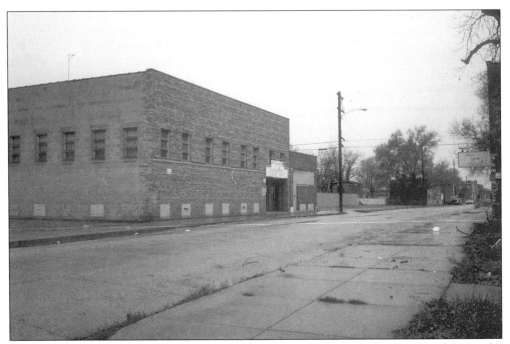

The Polish Home, at 1600 Pennsylvania Street, was a favorite local gathering place in the 1950s for weddings, political rallies, and other social events. The property sold in 1969.

# Seven
# 1958–1970

## "POKI SERCE BIJE TO JEST WSZYSTKO W PORZADKU"
### (AS LONG AS THE HEART BEATS, ALL IS WELL)

In the fall of 1958, St. Hedwig Parish celebrated its golden anniversary with a Solemn High Mass presided by the Most Reverend Andrew G. Grutka, Bishop of the Diocese of Gary. Father Louis Michalski served as the Celebrant of the mass, while Assistant Pastor Louis Wozniak was the master of ceremonies for the Jubilee Service. Four former assistant pastors of St. Hedwig—Rev. Wencel Karp, Rev. Louis Madejczyk, Rev. Valerian Karcz, and Rev. Joseph Sipos—participated. In the evening, Father Roman Wojciki, from Immaculate Heart of Mary Church in Independence Hill, served as toastmaster at a banquet in the school hall. Bishop Grutka spoke, and Mayor George Chacharis and the Honorable Judge A.B. Roszkowski offered their congratulations.

Parish membership then consisted of 1,430 members in 512 families. School enrollment remained steady at around 300, including 120 students from Blessed Sacrament Parish in West Glen Park where a new school was under construction. Eight sisters taught at St. Hedwig School under Principal and Sister Mary Carmel. Their meager salaries were based on tuition, which yielded each less than $800 per year.

Fraternal and social groups thrived. Third and even fourth generation Polish Americans now participated in parish life. Parents often signed up their children, while others came from recently arrived families. New chapters of the Polish National Alliance and the Polish Women's Alliance were founded. Dom Polski (the Polish Home), Cory Polski (the Daughters of Poland), and Wolna Polska (the Free Poland Society) remained active. Sophie Zukowski headed the Organization of St. Hedwig. Among other social clubs were Tadeusza Kosciuszki (Kosciuszko) Group 912, presided over by John Bajgrowwicz, and the Young Ladies Sodality of St. Hedwig.

Parish and school parent organizations continued to be popular among parishioners. The St. Cecelia Chior was directed by Eugene Zielinski and presided over by Elaine Wilson. Chester Dubrowski headed the Holy Name Society, while Sophie Pinkowski was president of the Holy Rosary Society, and the St. Hedwig Home and School Council was headed by Mary Bajgrowicz. Among the newer organizations were Klubu Matek II Wojny (Mothers of World War II) and the Polish-American Congress, Indiana Division, founded in 1944 by Walter Tolpa.

Among the many Polish-American businesses in the Central District in the late 1950s was Stanley Dabrowski's furniture store at 15th and Broadway. American Home Furniture Co., owned by Walter Tolpa, was a block south, while Frank Kampinski ran Broadway Sportland at 19th Avenue and Broadway. Casey A. Wachowiak ran an insurance agency in the 1500 block of Connecticut Street, and Pawinski and Rendina Funeral Service was located across the street from the church. Walter and Lottie Kolodzie owned a clothing store further east at 17th and Pennsylvania Street. The Pennsylvania Bakery continued to provide parishioners with bread and buns on the opposite corner. John Muraida ran a grocery store at 18th and Delaware, while Joe and Lillian Piegat owned Virginia Hardware at 18th and Virginia. Across the street, Joe and Sally Zawislak owned and operated a grocery and meat store. Along 17th Avenue, Hoosier Florist was run by Ted and Jean Sopkowski, and a few blocks east, Henry and Adele Ciesielski managed Albert's Tavern.

The busing of students from Glen Park to St. Hedwig ended in 1961 with the opening of Blessed Sacrament School. But the 70 pupils from the overcrowded St. Monica's School were assigned to St. Hedwig. Two separate classes of St. Monica's School were taught by Sisters of the Congregation of the Blessed Sacrament. Some St. Hedwig parishioners were concerned that the black (from St. Monica) and white children were attending the same school, but the students got along well.

In 1961, with 139 St. Hedwig students enrolled, Sister Mary Hermanegilde became principal. Thin enrollment forced 7th and 8th graders to share a single classroom with a single teacher.

Students and adults attended Polish cultural activities sponsored by the Polish Women's Alliance. Helen Zielinski and Lillian Warus directed a music and dance group that met on various days at St. Hedwig School Hall. The group performed plays throughout the region, and occasionally sang on WJOB radio. Helen Zielinski recalled that women in their 50s and 60s fought to get a part in Wyronda Corka, a modern prodigal daughter story. Some years later, as the Iron Curtain began to rust, tourism opened up, and a group of about 30 young people from St. Hedwig sang in Poland.

Many organizations and activities attracted Gary's Polish Americans to the mainstream American culture. Union membership was strong, and many second-generation Poles, following their parents' lead, were active in union affairs. Many joined the Democratic Party, and most voted the straight Democratic ticket. Their sons joined Little League, and played at Washington Park for such teams as Ace Cleaners and Virginia Hardware. Older children liked high school sports. Friday nights in the fall were reserved for football, and basketball dominated the winter weekends. Women joined neighborhood clubs and public school PTAs. Bonanza, Ed Sullivan, and Gunsmoke kept entire families glued to home television screens.

A renewal of Polish ethnic consciousness was inspired in 1966 by the celebration of 1,000 years of Christianity in Poland. Polish Americans in Northwestern Indiana organized parades, attended banquets, and sponsored a variety of cultural events. St. Hedwig Parish participated in many of the celebrations. Local groups presented special events and musical programs. As part of the grand occasion, Father Bernard Ciesielski of the Carmelite Fathers founded and directed the Millennium Chorus. The group gave a series of musical performances across the region, with Mrs. Evelyn Lisek as soloist, including one before some three thousand at Gary's Memorial Auditorium.

As the nation and the region experienced rapid social change, events in Southeast Asia touched the lives of many parishioners. The war in Vietnam prompted a huge build-up of military manpower and the revival of the draft. Like their fathers before them, St. Hedwig graduates went to war. All returned after their tour of duty, but Greg Klaja sustained severe injuries in the service of his country.

### Dedicated Service

*Parishioners of St. Hedwig fondly recalled the long and loyal service of parish janitor Walter Pienta. Stricken with a serious illness, he continued to dedicate his life to the care of St. Hedwig. Few individuals did more for the southside church from the late 1940s to the early 1970s.*

Social and economic changes accelerated in Gary's Central District during the late 1960s. Suburbia and an eroding customer base caused most family-run stores to relocate or close. The irresistible rise of Merrillville and its flagship shopping center, Southlake Mall, wracked Gary's tax base. The area surrounding St. Hedwig Parish became a land of derelict and boarded up buildings.

In August of 1980, the old school building was demolished. All that remained of a once-busy place was part of the front wall, an archway inscribed

"SW JADWIGA 1917 (St. Hedwig 1917)."

---

## St. Hedwig graduates who served in Vietnam included:

Dennis Noskoskie

Greg Klaja

Joe Mastalski

Ed Pasko

Zygmunt Swidkiewicz

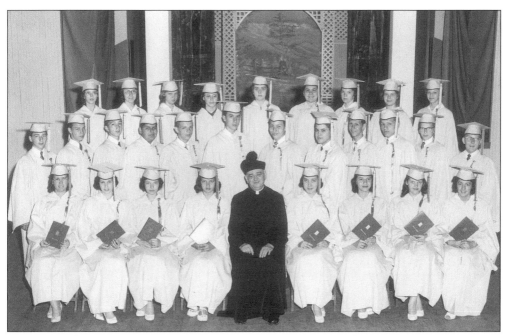

Diplomas in hand, the 8th graders of the Class of 1958 pose for their graduation picture with the Rev. Louis Michalski, pastor. The picture was taken in the upper hall of the school. (Courtesy of St. Hedwig.)

Rev. Louis Michalski's openness impressed many, if not all parishioners. Sometimes he found dealing with older and immigrant church members a bit difficult. Asked by illiterate parishioners to read letters from families in the old country, he was blamed for the contents. The good Father patiently suggested they find someone else to read letters and respond to relatives. Some left in anger, but most realized he was a man they could trust. He is seen here in 1958. (Courtesy of St. Hedwig.)

Seen here at his desk in 1958 is the Rev. Louis Wosniak. He served the parish as assistant pastor from 1950 until 1962. His dedication and easy-going manner endeared him to the parishioners of St. Hedwig Parish. (Courtesy of St. Hedwig.)

Baby-boomers who attended St. Hedwig School in 1958 will recall the Franciscan Sisters who taught there during the Golden Jubilee year. Pictured, from left to right, are: (seated) Sister Nazaria, Sister Carmel the principal, and Sister Celeste; (standing) Sister Quanita, Sister Leonida, Sister Edwinette, and Sister Elaine. (Courtesy of St. Hedwig.)

St. Hedwig's 50th Anniversary Banquet provided a great opportunity for parishioners and friends to get together. Here, Father Louis Wosniak (right) shares a few memories with Monsignor John Charlebois and Al Mysogland. (Courtesy of St. Hedwig.)

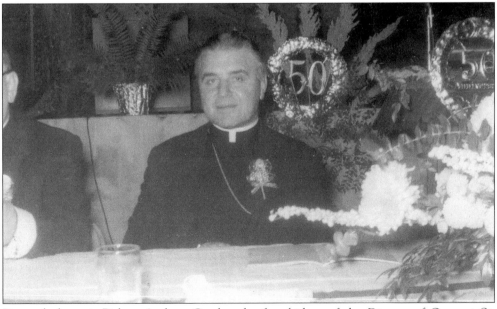

Pictured above is Bishop Andrew Grutka, the first bishop of the Diocese of Gary, at St. Hedwig's Golden Jubilee Banquet. Gary's Poles liked the new bishop. He was the son of Slovak immigrants, and as a young man had worked in the Open Hearth Department of U.S. Steel. (Courtesy of St. Hedwig.)

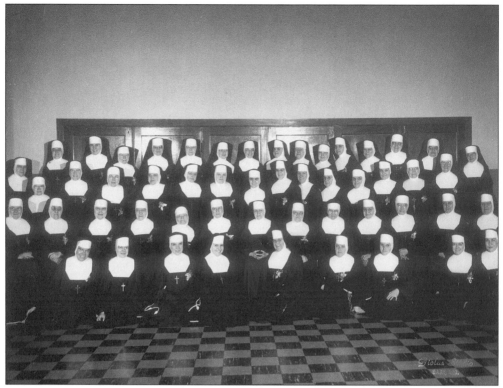

Special guests for the 50-year anniversary were the Franciscan sisters that taught at St. Hedwig School. Students and adults shared many fond—and sometimes amusing—memories with the sisters. The 1958 photo was taken in the upper hall of the school. (Courtesy of Helen Zielinski.)

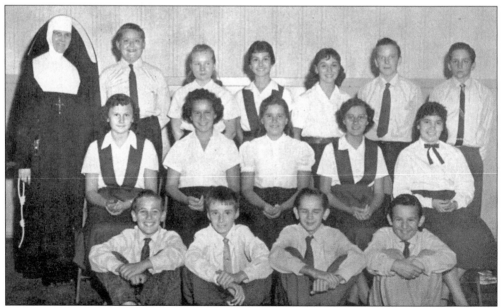

Sister Nazaria's Jubilee 8th grade class poses here. (Courtesy of St. Hedwig.)

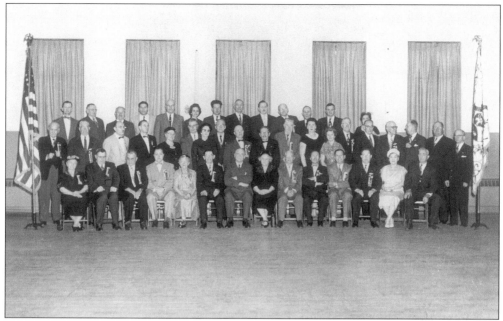

The P.N.A. Lodge, Group 912, organized their chapter in 1908. Here members of the original group pose for their 50-year anniversary picture in the upper hall of St. Hedwig Parish. (Courtesy of Calumet Regional Archives.)

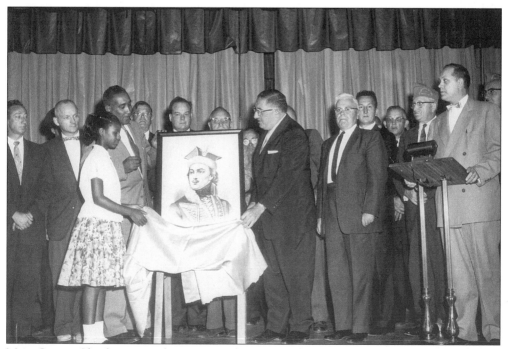

Mary George Chacharis unveils a portrait of Casimir Pulaski in the late 1950s at the Steel City school bearing the Revolutionary War hero's name. Looking on are students and faculty of Pulaski School, dignitaries, and members of American Legion, Post 207. (Courtesy of Calumet Regional Archives.)

In the late 1950s corner grocery and meat stores still took care of the St. Hedwig neighborhood clientele as few supermarkets were in operation. Sally's Grocery, at 18th Avenue and Virginia Street, was still a popular destination for food, meat, and the latest in community chatter. Seen above is Joe Zawislak at the meat counter and his wife Sally (below). (Courtesy of Alice Gurniewicz.)

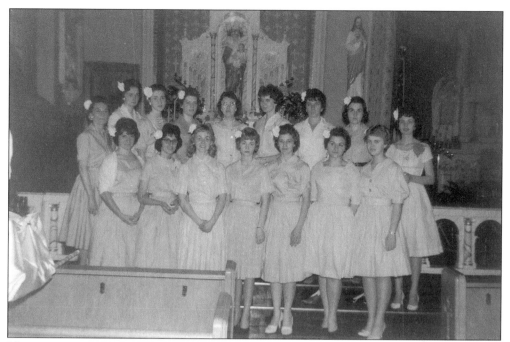

May crowning ceremonies of the Blessed Virgin Mary continued to be a special event in the late 1950s at St. Hedwig Parish. Girls from the upper grades of the school were selected to take part in the spring ceremony. Here the young ladies pose for a group picture at the altar of Mary. (Courtesy of Margaret Oleska.)

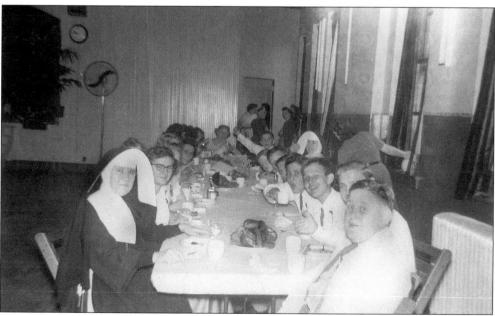

Principal of St. Hedwig, Sister Mary Carmel shares rolls of cakes and a few laughs with students in the cafeteria around 1960. Catholic school administrators knew most students on a first-name basis. (Courtesy of St. Hedwig.)

An early 1960s First Communion class sits with Monsignor Louis Michalski for the traditional group picture. Though the important day for them was Sunday, the next day they were the pastor's special guests for a big breakfast. (Courtesy of St. Hedwig.)

Happy Valentine's Day! In this picture, taken about 1960, the mothers of St. Hedwig's students remembered to wish the best to the school's dedicated sisters. (Courtesy of St. Hedwig.)

Monsignor Louis Michalski poses with a First Communion class during the early 1960s. The exact date is unknown, but the event was prior to the Second Vatican Council. Note that the main altar had not yet undergone any physical changes. (Courtesy of St. Hedwig.)

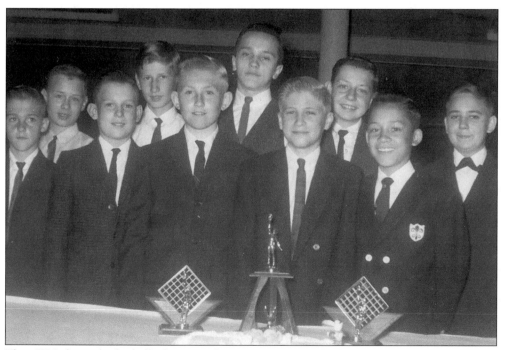

The CYO boys' basketball championship team poses with their victory trophy in 1963. (Courtesy of St. Hedwig.)

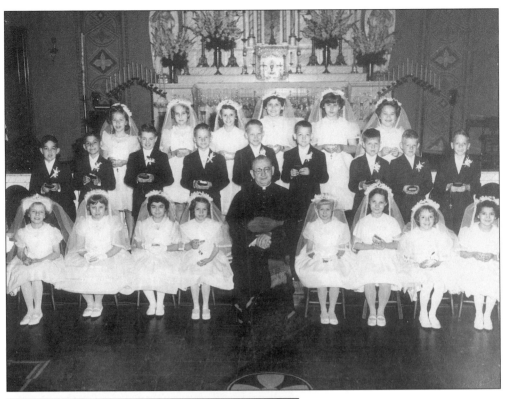

On May 19, 1963, the 3rd grade class of St. Hedwig received their First Communion. Seated with the youngsters is Monsignor Louis Michalski. (Courtesy of St. Hedwig.)

In the mid-1960s, Rosemary Kolodziej and Stanley Malocha took the vows of matrimony at St. Hedwig Church. The Rev. John Murzyn officiated the services. The main altar had changed in appearance following the Second Vatican Council. (Courtesy of Rosemary Malocha.)

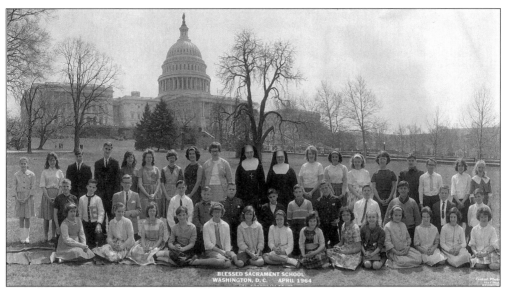

School trips to Washington D.C. were very popular during the 1960s. In April of 1964, Sister Hermenegilde and Sister Elaine took a combined group from Blessed Sacrament and St. Hedwig to the nation's capital. (Courtesy of John Trafny.)

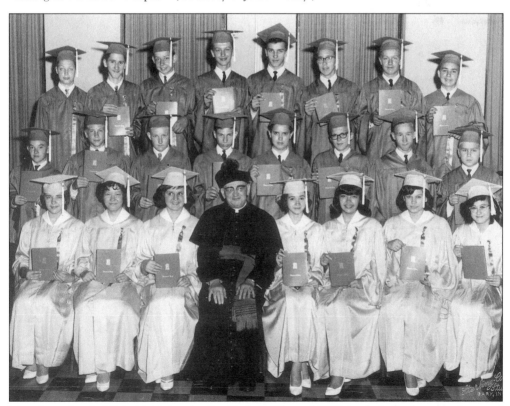

Monsignor Louis Michalski joins the St. Hedwig Class of 1964 in their final group picture of the school. The group was part of the baby-boom generation that was born after 1946. (Courtesy of St. Hedwig.)

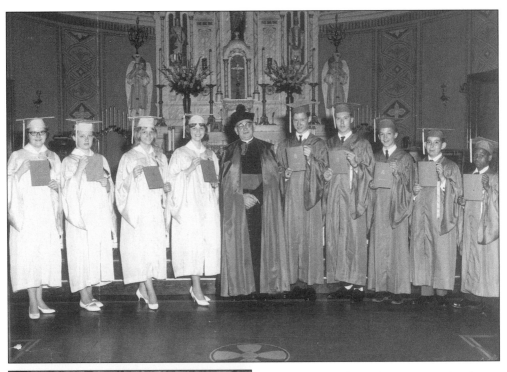

St. Hedwig's Class of 1965 posing for their graduation picture before the main altar. At center is the pastor, the Rev. Louis Michalski. (Courtesy of St. Hedwig.)

In August of 1965, Monsignor Louis Michalski was transferred to a parish in Michigan City. He left St. Hedwig with renovated parish buildings and a handsomely restored church interior. The beautiful artwork and the altars had been restored to their original colors. Father Michalski had also begun the purchase of properties along the 1700 block of Pennsylvania Street. (Courtesy of St. Hedwig.)

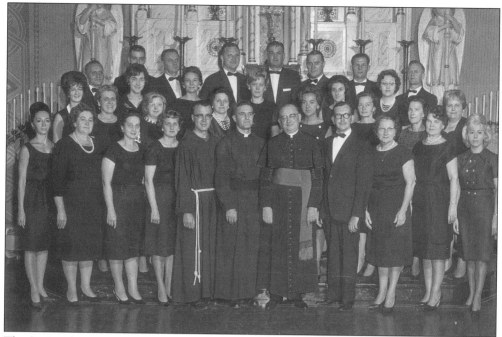

The St. Cecilia Choir of St. Hedwig continued to present the beauty of traditional Polish music in the 1960s. Director Eugene Zielinski is to the right of Monsignor Louis Michalski. (Courtesy of St. Hedwig.)

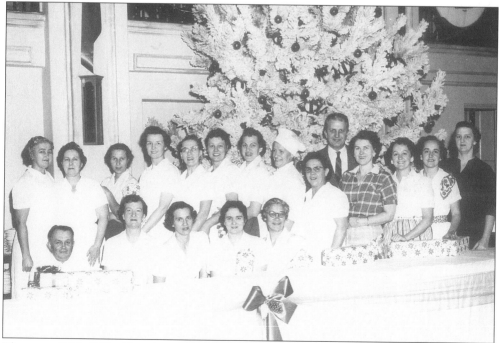

The ever affable Eddie Nowak and his staff at the Marquette Park Pavilion at Christmas in the early 1960s. Under his direction, social events such as weddings, proms, parties, and political gatherings were always a pleasant experience. (Courtesy of Calumet Regional Archives.)

The Rev. Brian Braun was a Capuchin priest who resided and assisted at St. Hedwig from 1964 until 1966. (Courtesy of St. Hedwig.)

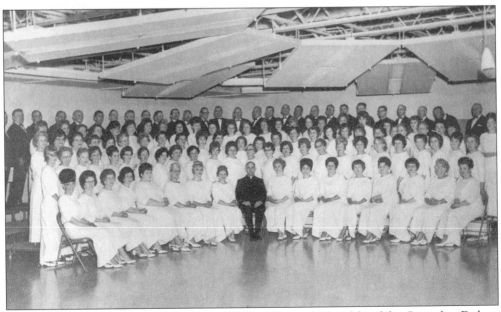

To commemorate the Polish Millennium, the Rev. Bernard Ciesielski of the Carmelite Fathers of Munster organized a 140-member chorus. In May of 1966, the group performed before 3,000 people in Gary's Memorial Auditorium. Father Ciesielski assisted at St. Hedwig during the late 1940s and early 1950s. (Courtesy of Calumet Regional Archives.)

1966

## Souvenir Program

of

# Thirty Fifth Anniversary

of

## Polish American Democratic Club

OF GARY, INDIANA

# Banquet and Ball

SATURDAY, FEBRUARY 12, 1966

POLISH HOME HALL

1600 Pennsylvania — Gary, Indiana

GARY, INDIANA

5:00 p.m.

Polish Americans were generally Democratic during the 1960s. Here is a program from the 35th Anniversary Banquet held at the Polish Home in 1966. (Courtesy of Calumet Regional Archives.)

Father Casimir E. Senderak was appointed pastor of St. Hedwig in August of 1965, replacing Monsignor Louis Michalski. His previous assignments in the Gary Diocese included St. Thomas Aquinas in Knox, St. Mary's in Hammond, and Holy Family in Gary. He also served as the Vicar General of the Diocese of Gary. Following his retirement, the Rev. Senderak spent his remaining years at the Albertine Home in Hammond. (Courtesy of St. Hedwig.)

Father John A. Murzyn first served as assistant pastor at St. Hedwig Parish beginning in 1962. He worked under the Rev. Louis Michalski then the Rev. Casimir Senderak. In October of 1968, Father Murzyn assumed the duties of pastor of St. Hedwig. In 1975, he became pastor of Assumption Parish in New Chicago. Today he enjoys his retirement in Hawaii. (Courtesy of St. Hedwig.)

Like the young men of previous generations, St. Hedwig graduates answered their nation's call to duty. Joseph S. Mastalski served in the Marine Corps. In 1966. He was with the 5th Communications Batallion in South Vietnam.

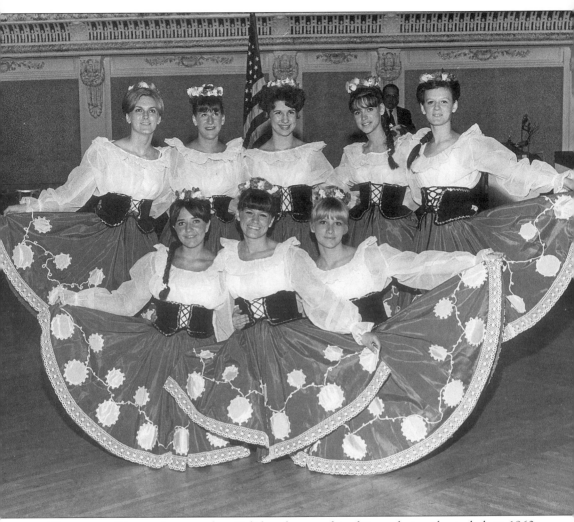

The young did not always neglect Polish culture and traditions during the turbulent 1960s. Three young ladies from St. Hedwig part of the Polish dance group from Hammond that competed at the Sherman House in Chicago during the summer of 1966. Pictured in the front row, from left to right: Joyce Noskoskie, Stasia Mastalski, and Diane Lelek. (Courtesy of Dennis Noskoskie.)

# *Eight*
# 1970–PRESENT

## LATA *DZIECIECE TO SA MOMENTY CO CZLOWIEK*
## *PAMIENTA*
## CHOCIAZ *BY PRZEZYL TYSIAC LAT.*
### (THE YEARS OF ONE'S CHILDHOOD WILL ALWAYS BE CHERISHED EVEN IF ONE SHOULD LIVE TO BE ONE THOUSAND YEARS OLD.)

As the 1970s ended, several events and individual accomplishments brought pride to the remaining parishioners of St. Hedwig. In the fall of 1978, Cardinal Karol Wojtyla of Krakow became Pope John Paul II. St. Hedwig was astounded: few expected a non-Italian to be chosen Bishop of Rome, let alone a Pole from behind the iron curtain. Joyous parishioners attended a Mass of Thanksgiving for the elevation of a Polish Cardinal. Helen Zielinski, president of the National Polish Women's Alliance, was especially delighted. She had met Cardinal Wojtyla during his visits to Chicago, and, while in a Chicago hospital, was honored with a personal visit by the cardinal. She attended the inaugural celebration for John Paul II in Rome, and, over the next few years, met him six times in private audiences and at a luncheon for officials of the Polish Alliance.

During the Solidarity Crisis in Poland, St. Hedwig's parishioners, like Polish Americans everywhere, worried about their overseas families and friends. As the movement gathered strength, many feared a Hungarian-style uprising. Many cheered when Vice-President George Bush placed the traditional red and white Polish flag bearing an eagle at the tomb of the Unknown Soldier in Warsaw. The Polish Communist regime, which had banned that version of the flag, was insulted, while Bush suddenly became a popular figure among Polish Americans.

On September 20, 1983, Father John Siekierski left St. Hedwig to become Pastor of Blessed Sacrament Church in Glen Park, and was succeeded by The Rev. Henry Lazarek. During Father Siekierski's years of service, the church had been repainted, the 10 A.M. Sunday Mass was celebrated in Polish, and plans were made for celebration of the Diamond Jubilee celebration of St. Hedwig. With help from Miss Helen Rzepka, Mrs. Helen Lis, and Mrs. Helen Zielinski, Father Siekierski collected historical information and photographs for the *75th Anniversary Booklet of St. Hedwig Church.* On October 16, 1983, St. Hedwig Parish celebrated its Diamond Jubilee. A special mass was celebrated in the church by former St. Hedwig priests Reverend Casimir Senderek, Louis Wosniak, John Siekierski, John Murzyn, and George Dubowski. Following the mass, a dinner was held at the Salvatorian Hall with over four hundred parishioners and guests in attendance. Old friends and classmates happily shared memories.

In the mid-1980s, the aging parish faced its most serious challenge: the possibility that St. Hedwig Church might close. Almost two-hundred families still belonged to the parish, but the Diocese faced a growing shortage of priests. First the Parish Council and then the shocked and dismayed congregation met to discuss and debate the eventuality of closing. Speaking in Polish and English, Bishop Norbert Goughn assured the congregation that St. Hedwig would remain open as a mission church, but with no pastor in residence. The Parish Council and parishioners would manage the day-to-day operations of the church.

Salvatorian priests would come from Merrillville to celebrate Sunday Masses and other religious services. The Salvatorian priests that served St. Hedwig were: Rev. Zenon Buczek, Rev. Josef Juziak, Rev. Karol Stawowy, Rev. Edward Kawa, and the Rev. Thaddeus Majcher.

Perhaps its small membership allowed the St. Hedwig family to become more close-knit. St. Hedwig always exceeded its assigned goal for Diocesan Appeals. Parish Bingo events and picnics attracted large numbers of active and former parishioners. Parishioners also contributed generously to church maintenance. Gifts came from former members as far away as Florida and Ohio. Parishioners also donated there time and labors to the church.

In 1988 and 1993, past and present parishioners and guests of St. Hedwig gathered to observe the 80th and the 85th anniversary of the church. Those afternoons of good food, good friends, and shared memories were held at the Salvatorian Hall and picnic grounds in Merrillville. In 1996 the Lake County Historic Preservation Coalition compiled a list of over 1,000 buildings eligible for landmark status with the National Register of Historic Places. St. Hedwig Church was one of the structures suggested for preservation, and parish director Dennis Noskoskie began the application process.

St. Hedwig Church continued its spiritual mission to the community, but in the spring of 1998, the last Polish-owned business in the community closed its doors when Sally Zawislak sold her Virginia Street grocery store. She and her late husband Joe had been in business since 1951, operating first a tavern and later the store. The only surviving Central District businesses had long since moved to Glen Park or Merrillville.

A handful of Polish families remained active in St. Hedwig Church. Most lived in Glen Park, Merrillville, South Lake County, and even Porter County. Job changes had taken some out of state, and many retirees had moved to warmer climates. To an extent, those events were part of the continuing American Dream. Polish Americans like other Americans, bought homes in suburbia, and hoped to spend their "golden years" in Florida or Arizona.

Moving out of the old neighborhood did not mean leaving St. Hedwig. Many continued their old association, some as active members, while others, now members of a distant parish, periodically attended Sunday services. Some had been baptized and married at St. Hedwig, others had graduated from the school. Older folk liked to hear mass in Polish. Many retained a strong affection for the church that their parents or grandparents had built.

As 2000 ended, plans were underway for a St. Hedwig reunion to be held sometime in 2001.

In 1946 Frank Capra produced and directed the classic film *It's A Wonderful Life*, in which the leading character gradually discovered how many lives he affected. Like Capra's fictional George Bailey, St. Hedwig Church has, for 90 years, touched the lives of thousands. Since 1908, the old church has borne witness to 6,429 baptisms; over 3,000 individuals took the vows of matrimony. Thousands of children either attended or graduated from the school.

The first Polish immigrants who came to the region built St. Hedwig Parish and founded the surrounding community. They created religious and social organizations that tied them to their church, neighborhood, and each other. St. Hedwig School provided their children and grandchildren an education, nurtured old customs, and helped them enter the American mainstream. Americanization sent many on separate paths, yet they still return to St. Hedwig—the church of their ancestors.

St. Hedwig School continued its academic and spiritual mission well into the 1970s. From 1917 until 1942, the building's 3rd floor served as the parish church. Sometimes that posed a problem for pallbearers during funerals. It is seen here about 1974. (Courtesy of St. Hedwig.)

For many years the Klososki family owned and operated the White Eagle Hall on East 17th Avenue. It served the neighborhood as a tavern and social hall. Today it is a local VFW hall. (Courtesy of John Trafny.)

Walter and Sophie Kolodziej finish a day at the family business in December of 1971. The establishment continued into the 1970s. (Courtesy of Rosemary Malocha.)

Granddaughter Lynn Malocha plays with her friend outside the store. To the right is Boleski's Bakery. (Courtesy of Rosemary Malocha.)

With fewer sisters available to teach in the Diocese of Gary Schools, more lay teachers were hired to meet the educational demands. In the early 1970s, Mrs. Bernice Tanner Richardson became St. Hedwig's first lay principal. (Courtesy of St. Hedwig.)

It takes a good number of people to make sure a school functions properly. Here Mrs. Lillian Peck and Mrs. Grizelda Smith—the school cooks— make sure the student's nutritional needs are met. The picture was taken in the mid-1970s. (Courtesy of St. Hedwig.)

St. Hedwig students continued to be involved in extra-curricular activities after their class day. Above it the boys' basketball team and below are the girls cheerleading squad. Both pictures were from the 1975–1976 school year. (Courtesy of St. Hedwig.)

The Rev. Hilary Halter, OFM, worked a series of assignments before being appointed pastor of St. Hedwig in 1975. His duties ranged from parish priest, assistant production manager for Franciscan Publishers, and supply director. Because of his health, Father Hilary was transferred to the friary in Cedar Lake. He spent his last days at St. Anthony Medical Center in Crown Point. (Courtesy of St. Hedwig.)

For many years, American Legion members of the Tadeusz Kosciuszko, Post 207 had their headquarters at 15th Avenue and Pennsylvania Street. The property was sold during the 1970s. Today the building is a church and social hall. (Courtesy of John Trafny.)

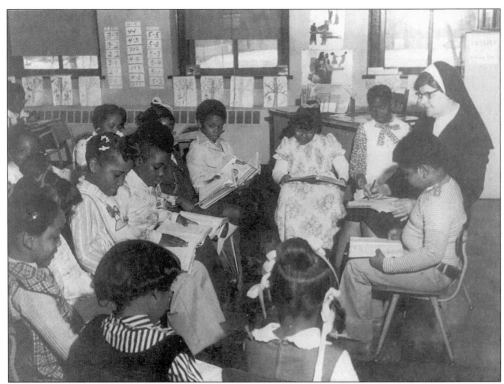

Sister Mary Edwinette Wisz works with her 1st grade class in the late-1970s. With the closing of St. Hedwig School, students were moved to the vacant Holy Rosary School on Clark Road. The building was referred to as St. Hedwig West. (Courtesy of St. Hedwig.)

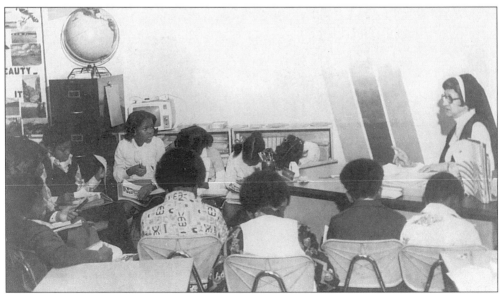

Students pay close attention to the day's lesson given by Sister Louise Nowicki. By the late 1970s only two sisters taught at St. Hedwig School. (Courtesy of St. Hedwig.)

Evelyn Lisek and Frank Roman share a few moments at an ethnic gathering at Gary's Marquette Park in 1977. Mrs. Lisek was soloist for the Millennium Chorus, and for many years she worked to promote Polish culture throughout the Calumet Region. Mr. Roman was a teacher at Gary's Horace Mann High School. During the Second World War he was held in a Russian prison camp. (Courtesy of Calumet Regional Archives.)

Since his days as a student at St. Hedwig School, Thomas Zakrzewski was interested in space travel. He achieved his dream as he took part in the design of America's Space Shuttle. He is pictured here while a student at Purdue University in 1972. (Courtesy of a school buddy.)

Frank Roman shares a few stories and old memories with Mr. and Mrs. Tony Zale at a Silver Bell Club Banquet in the late 1970s. Special guests at the annual events included such sports greats as Hank Stram and Lou Holtz. (Courtesy of Calumet Regional Archives.)

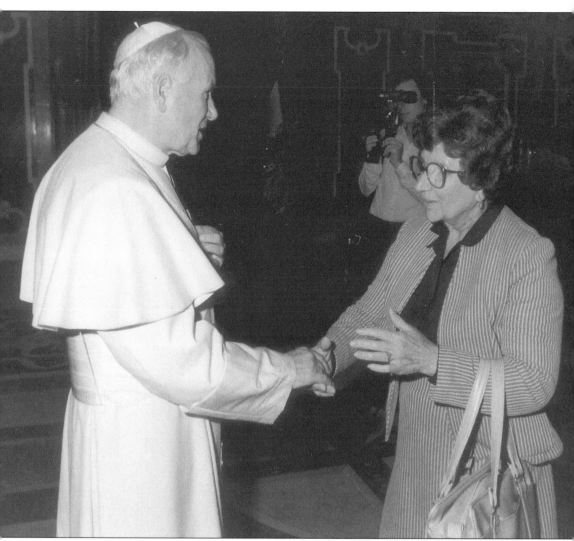

Longtime St. Hedwig parishioner and National President of the Polish Women's Alliance, Helen Zielinski greets Pope John Paul II at the Vatican in the late 1970s. She had the honor of meeting with the Pontiff on several occasions. Mrs. Zielinski's friendship with the Pope actually went back to the days that he served as Bishop of Cracow, Poland. (Courtesy of Helen Zielinski.)

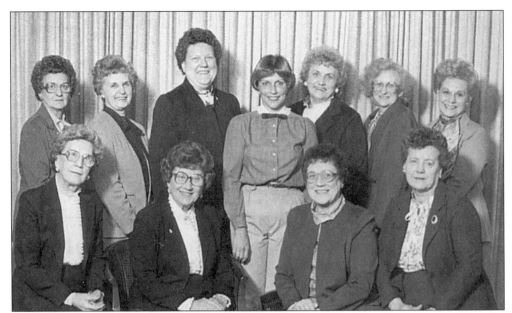

Queen of Peace Society, Group 815, pose for a group photo in the early 1980s. (Courtesy of St. Hedwig.)

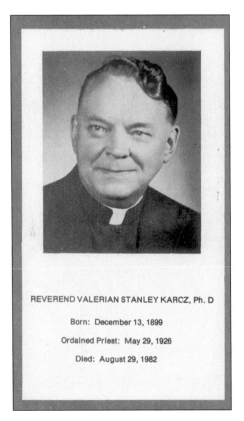

REVEREND VALERIAN STANLEY KARCZ, Ph. D

Born: December 13, 1899

Ordained Priest: May 29, 1926

Died: August 29, 1982

Above is the remembrance card for the funeral of former assistant pastor, the Rev. Valerian Karcz, Ph.D., who passed away in 1982. Father Karcz served St. Hedwig from 1931 to 1935. (Courtesy of St. Hedwig.)

Every year volunteers from the parish put in time and effort during the Christmas season to decorate the church and construct a beautiful nativity scene. The traditional stable is set before the side altar of St. Joseph (below). (Courtesy of St. Hedwig.)

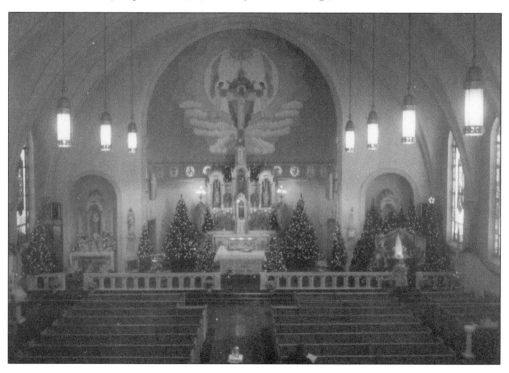

Pictured here is Brother Ralph Talaga, C.S.C. (Courtesy of Rose Nalbor.)

Father Tony Chojnacki, OFM, displays his new look in March of 1981. (Courtesy of St. Hedwig.)

Mrs. Johnnie Mae Aldrich became St. Hedwig's first African-American parishioner in the mid-1960s. She and her husband came from Macon County, Georgia. Like previous settlers from the Central District, the Aldrich family had come to Gary for a good job and a better life. She is pictured here with her daughter Charlotte and son Charles in 1982. (Courtesy of Charlotte Aldrich.)

*Saint Hedwig Parish*

*requests the honour of your presence*

*at the*

*Mass Of Thanksgiving*

*Saint Hedwig Church*

*Eighteenth Avenue and Connecticut Street*

*Gary, Indiana*

*on the occasion of it's*

*Seventy-Fifth Anniversary*

*Sunday, the sixteenth day of October*

*Nineteen hundred and eighty-three*

*at four o'clock in the afternoon*

*and*

*Jubille Banquet and Ball*

*Salvatorian Millennium Hall*

*5755 Pennsylvania Street*

*Merrillville, Indiana*

*Cocktails at six          Dinner at seven*

In 1983, St. Hedwig Parish celebrated its 75th anniversary. A Thanksgiving Mass took place at the church followed by a banquet at the Salvatorian Millennium Hall. Special invitations were printed for parishioners and guests. (Courtesy of John Murida.)

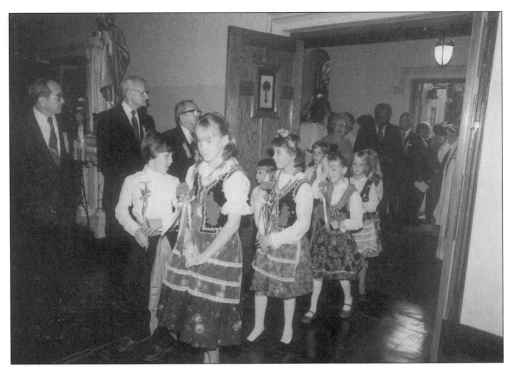

St. Hedwig's Diamond Jubilee in 1983 was an event of great joy and celebration. It was also a time to look back upon parish roots. Here, children and grandchildren of parishioners enter the church in traditional Polish garb before mass. (Courtesy of St. Hedwig.)

Parishioners bring the offertory gifts to the altar during the Jubilee Mass. (Courtesy of St. Hedwig.)

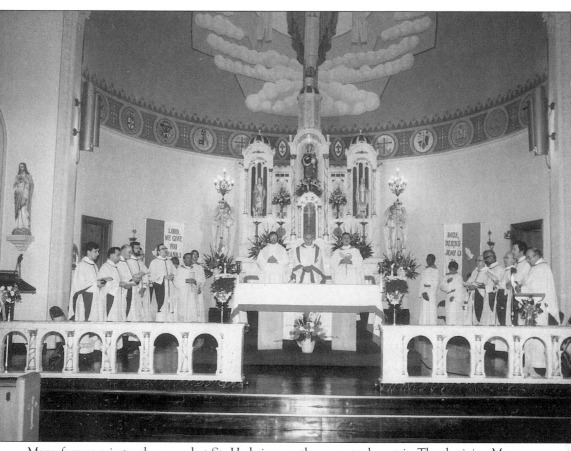

Many former priests who served at St. Hedwig over the years took part in Thanksgiving Mass. They included former pastors, assistants, and Salvatorians. (Courtesy of St. Hedwig.)

In 1983, Rev. Henry Lazarek was appointed pastor of St. Hedwig. He began has pastoral duties during a time of great jubilation for the congregation. St. Hedwig was in the midst of its Diamond Jubilee celebration. But with the shortage of priests in the Diocese, St. Hedwig became a Mission Church. With his departure, Father Lazarek became the last resident pastor of St. Hedwig. (Courtesy of St. Hedwig.)

Many students, teachers, and parishioners passed through the main entrance of St. Hedwig School. Life-long friendships were made by many. In the late 1970s the doors closed forever. All that stands today is the old arch. Still, the memories continue. (Courtesy of John Trafny.)

In the late 1990s, the last Polish-owned business in the St. Hedwig neighborhood closed its doors. Sally's Grocery was owned and operated by the Zawislak family since the early 1950s. (Courtesy of Sally Zawislak.)

Sister Louise.

Sister Elaine Bartkowski.

Sister Mary Eymard Sanok.

Sister Mary Edwinette Wisz.

Sister Mary Edurma.

Sister Dorothy Szostek.

Sister Bernice Marie Junio.

Though St. Hedwig Parish today is a Mission Church with no resident pastor, the Salvatorian Fathers have continued to see to the spiritual needs of the parishioners. The Rev. Josef Juziak, next to the banner of the parish patron saint, serves as chief administrator. This picture was taken on October 15, 2000.

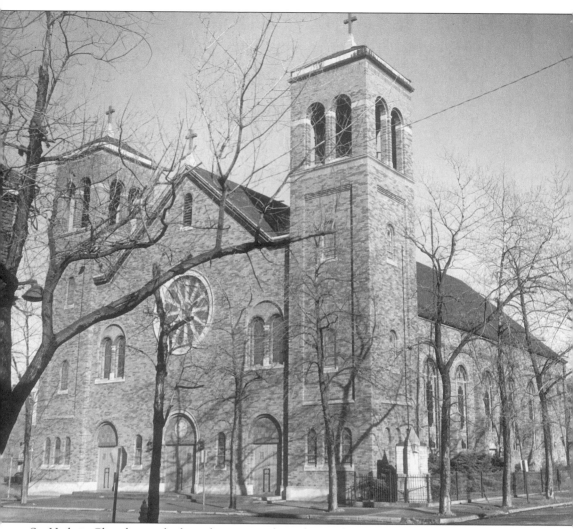

St. Hedwig Church as it looks today as seen from the southwest side of the building at 18th Avenue and Connecticut Street. (Courtesy of St. Hedwig.)

# AFTERWARDS

In 1998, my research work on *The Polish Community of Gary* took me to the Central District, the old neighborhood that my ancestors, and many other families, once called home. It was an area of great contrast. The Polish immigrants were long gone when I began to seek material for my story. Their descendants scattered through the region, and beyond. The old neighborhood bore the scars of many years of economic decline and unkempt political promises. Conditions were similar to those of many old immigrant neighborhoods throughout urban America.

I found much of the immediate area surrounding St. Hedwig Church consumed by the urban blight so common in many of the nation's older cities. Burned-out and crumbling structures stood as ghostly reminders of an era that once was. Many of the old buildings were vacant, abandoned over a generation ago. In other places, weed strewn vacant lots were all that remained of once-thriving establishments such as the Pennsylvania Bakery, Pawinski Funeral Home, and the Silver Bell Club.

My perception of the community changed as I traveled along 15th Avenue. Newer, split-level ranch homes intermixed with older residential structures. The tree-lined streets north of 15th Avenue presented a stable, residential community of well-kept brick houses and apartments. Further west, I discovered signs of gradual renewal along Broadway, between 11th and 15th Avenues. A new strip mall was in operation across the street from the police station, while another was near completion a few blocks to the north. New apartments and townhouses were just west of Broadway, some along the very streets that long ago were part of the infamous "Patch." Even the area near St. Hedwig Church had undergone some improvement as streets were resurfaced, and a number of old buildings demolished.

In the midst of ruin and renewal stood St. Hedwig Church continuing its spiritual mission. Parishioners, as well as many residents of the Central District, looked upon the church as survivor of the challenges the neighborhood faced over the years. St. Hedwig was a monument to the American success story as Polish immigrants and their children from the Central District toiled in the mills and struggled to raise families while on their journey to mainstream America. Assimilation was the goal and St. Hedwig School was the vehicle that took them their. The children were educated, became successful, and moved on to the suburbs and elsewhere as Americans.

Back in the 1970s, I was assigned to the 3rd Armored Division in West Germany. During my tour of duty there, I had the opportunity to visit many historical sites. Some were churches centuries old and still in use. Europeans respected history and tried to preserve their links to the past. Unfortunately in the United States, grand structures were left to deteriorate and fall to the wrecking ball. New suburban churches often resembled convention halls and not houses of worship. Architectural and historical ties to the past were lost forever.

Long ago immigrant groups built their own national churches in the inner cities, often within a few blocks of one another. Each group wanted their own house of worship where they shared a common language and traditions with their neighbors. The closeness was further enhanced, as it was an era of walking to church or taking a streetcar. With the development of the interstate highway system and the growth of the suburbs, Catholic churches in the region's cities were left with fewer members. Financial problems and the shortage of priests presented additional woes. Parish life came to an end at such immigrant Steel City churches as Holy Trinity, Sacred Heart, and St. Casimir. Only St. Hedwig remained in the heart of the city.

Ninety years have passed in the life of St. Hedwig Parish. Its Polish and African-American flock contributed countless hours towards its upkeep and preservation. The job was difficult and thankless. For St. Hedwig to continue into the 21st century, a united effort to preservation would be called for between the parish, city, and the Diocese of Gary. Hopeful signs have emerged as work continued on placing the church building on the National Register of Historic Places. Recently, Gary was designated an Empowerment Zone where federal assistance along with private investment would be available for further residential and commercial development in the Central District. Should the residential population increase, St. Hedwig would be there to serve the community's Catholics. It will only happen with vision and commitment.

# BIBLIOGRAPHY

Bodnar, John Roger Simons, and Weber, Michael P. *Lives of Their Own, Blacks, Italians, and Poles in Pittsburgh, 1900–1960.* 1983.

Brody, David. *Steelworkers in America, the Nonunion Era.* 1960.

Bukowczyk, John J. *And My Children Did Not Know Me, A History of Polish-Americans.* 1987.

Cohen, Ronald D., and Lane, James B. *Gary, A Pictorial History.* 1983.

Dubofsky, Melvyn, ed. *American Labor Since the New Deal.* 1971.

*Federal Writers Project, the Calumet Region Historical Guide Compiled by the Workers of the Writers Program of the W.P.A.* 1939.

Glaab, Charles N., and Brown, Theodore A. *A History of Urban America.* 1976.

Golab, Caroline. *Immigrant Destinations.* 1977.

Greer, Edward. *Big Steel, Black Power, and Corporate Power in Gary, Indiana.* 1979.

Hernandez, Ernie. *Ethnics in Northwest Indiana.* 1984.

Knawa, Sister Anne Marie. *As God Shall Ordain, A History of the Franciscan Sister of Chicago, 1894–1987.* 1989.

Lane, James B. *A City of the Century, A History of Gary, Indiana.* 1978.

Liptak, Delores, R.S.M. *Immigrants and Their Church.* 1989.

Mirecki-Piergie, Mary. *A Collection of Polish Proverbs and Sayings.* 1989.

Mohl, Raymond A., and Betten, Neil. *Steel City, Urban and Ethnic Patterns in Gary, Indiana 1906–1950.* 1986.

Noll, the Most Reverend John F. *The Diocese of Fort Wayne, Fragments of History, Vol. II.* 1941.

Pacyga, Dominic A. *Polish Immigrants and Industrial Chicago, Workers on the South Side, 1880–1922.* 1991.

Parot, Joseph John. *Polish Catholics in Chicago, 1850–1920, A Religious History.* 1981.

Pienkos, Angela T. *Ethnic Politics in Urban America, the Polish Experience in Four Cities.* 1978.

Taylor, Philip. *The Distant Magnet, European Emigration to the U.S.A.* 1971.

Taylor, Robert Jr., and McBirney, Connie. *People in Indiana, the Ethnic Experience.* 1996.